The Complete Guide to Eco-Friendly Design

The Complete Guide to
ECO-FRIENDLY DESIGN

Poppy Evans

NORTH LIGHT BOOKS
CINCINNATI, OHIO

This hardcover edition of *The Complete Guide to Eco-Friendly Design* features a "self-jacket" that eliminates the need for a separate dust jacket. It provides sturdy protection for your book while it saves paper, trees and energy.

Other fine North Light Books are available from your local bookstore, art supply store or direct from the publisher.

01 00 99 98 97 5 4 3 2 1

Library of Congress Cataloging in Publication Data

Evans, Poppy.
 The complete guide to eco-friendly design / by Poppy Evans. —
1st ed.
 p. cm.
 Includes index.
 ISBN 0-89134-724-0 (pob. : alk. paper)
 1. Printing—Environmental aspects. 2. Printing—
 Environmental aspects—United States. I. Title.
 Z244.E93 1997
 686.2—dc20
 96-13160
 CIP

Edited by Dawn Korth
Designed by Sandy Conopeotis Kent

The permissions on page 138 constitute an extension of this copyright page.

North Light Books are available for sales promotions, premiums and fund-raising use. Special editions or book excerpts can also be created to specification. For details, contact: Special Sales Manager, F&W Publications, 1507 Dana Avenue, Cincinnati, Ohio 45207.

METRIC CONVERSION CHART		
TO CONVERT	TO	MULTIPLY BY
Inches	Centimeters	2.54
Centimeters	Inches	0.4
Feet	Centimeters	30.5
Centimeters	Feet	0.03
Yards	Meters	0.9
Meters	Yards	1.1
Sq. Inches	Sq. Centimeters	6.45
Sq. Centimeters	Sq. Inches	0.16
Sq. Feet	Sq. Meters	0.09
Sq. Meters	Sq. Feet	10.8
Sq. Yards	Sq. Meters	0.8
Sq. Meters	Sq. Yards	1.2
Pounds	Kilograms	0.45
Kilograms	Pounds	2.2
Ounces	Grams	28.4
Grams	Ounces	0.04

ACKNOWLEDGMENTS

A book like this is only possible with the help and cooperation of many people. First of all, I would like to thank editorial director David Lewis and my editor, Lynn Haller, for initiating this project and giving me the opportunity to work on it. I would also like to thank Dawn Korth, whose editorial advice and suggestions helped so much to pull this book together, and Bob Beckstead, who guided it through production.

I would like to thank several experts whom I contacted frequently to compare notes and ask questions: Jerry Kuyper and Brian Collins, who have a wealth of knowledge on designing in environmentally responsible ways, and Rick London, an authority on eco-friendly prepress and printing production. They also helped by steering me in the direction of other designers who are equally committed in their work.

Finally, I want to thank the designers who contributed such great projects to this book. Not only is their willingness to share their work and ideas with other designers worthy of recognition, their efforts to protect and preserve our planet by producing environmentally sound printed materials are highly commendable.

About the Author

After graduating from the University of Cincinnati with a degree in fine arts, Poppy Evans got her first taste of publishing by functioning as a one-person production staff, writing, editing and laying out a company newsletter. She has worked as a graphic designer and as a magazine art director for Screen Printing and the American Music Teacher, a national association magazine that won many awards for its redesign and artfully conceived covers while under her direction.

Poppy returned to writing and editing in 1989, as managing editor of HOW magazine. Since leaving HOW, she has written many articles that have appeared in graphic arts magazines, including Print, HOW, Step-By-Step, Publish, Single Image and Confetti. She is the author of several books on graphic design and teaches graphic design and computer publishing at the Art Academy of Cincinnati.

TABLE OF CONTENTS

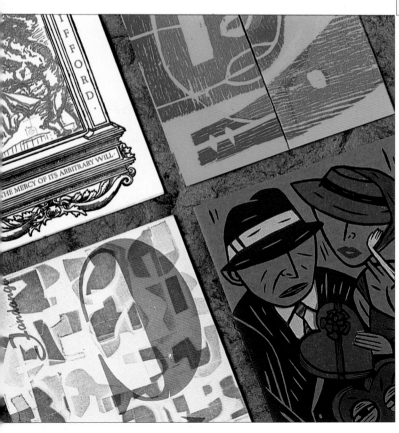

Most of us want to be responsible when it comes to protecting and preserving our planet's resources. We consider ourselves to be model citizens of planet Earth when we conserve energy and recycle our trash. But as graphic designers, we're asked to go further than that and to make a difference by designing and producing environmentally sound printed materials.

This isn't as easy as it may seem. Eco-friendly design often demands concepts that will look good on unbleached paper with a high recycled content. It also means forgoing many harmful finishing techniques and limiting ink and varnish coverage. This can be inhibiting to many of us who want to dazzle our clients and, at the same time, stimulate our own creative instincts.

Although many designers may cringe at the idea of having these limitations imposed on their work, others have produced highly effective, award-winning designs that also happen to be environmentally sound. Much of this outstanding work appears in this book.

The Complete Guide to Eco-Friendly Design offers much more than an opportunity to learn about earth-friendly materials and techniques. It offers the chance to learn from others who have worked successfully with these materials and techniques and have pleased their clients by producing innovative, earth-friendly design projects that represent smart, economical design at its best.

Environmentally Friendly Paper Choices

Choosing the most environmentally friendly paper is not quite so simple as selecting one labeled "recycled." Environmentally aware designers need to consider the content of the paper (its pulp source and recycled content), the wastes generated in the recycling process (if paper content is recycled), and the paper's likelihood of recyclability or ability to break down in the landfill after it's been printed and used.

In this chapter you'll find out how to make sound judgments when selecting recycled papers, what to expect on press, and what you can expect to pay for a recycled stock. You'll also learn about alternatives to traditional printing papers that conserve resources and yield interesting results.

Recycled Content

For starters, you need to check the percentage of recycled content in the paper you're considering. Most commercial printing papers are made from wood chips that are chemically treated and reduced to fiber. The fiber produced in this process is referred to as *virgin fiber.* Obviously, papers made entirely from virgin fiber consume the most trees. Conversely, using paper composed entirely or partly of recycled fibers helps conserve our forests.

Most paper manufacturers use a combination of virgin fiber and recycled paper in their papers. The recycled scrap used in the papermaking process can be broken down into two categories: preconsumer and postconsumer waste. *Preconsumer waste* includes envelope trimmings, paper mill scraps, and unsold shredded magazines that never reached the newsstand—in other words, paper recovered from the manufacturing process. This type of scrap has always been used in papermaking; in fact, paper manufacturers often refer to this waste as *mill broke.*

Paper that has previously been used by consumers and recovered through recycling is referred to as *postconsumer waste.* Postconsumer waste is paper that otherwise would have ended up in the landfill. The chart on page 19 gives the percentages of preconsumer and postconsumer waste content of some common printing papers.

In December 1994 the Clinton administration issued an executive order that set guidelines for the government's use of recycled papers. Since the federal government is the single largest consumer of paper in the country, these guidelines have great influence on what the paper industry now considers recycled paper to be. The executive order calls for a minimum content standard of 20% postconsumer waste for most office papers used by the federal government. Furthermore, the executive order stipulates that "this standard shall be increased to 30% beginning on December 31, 1998." The executive order further defines what constitutes recycled papers: "other uncoated printing and writing paper, such as writing and office paper, book paper, cotton fiber paper, and cover stock, the minimum content standard shall be 50% recovered materials, including 20% postconsumer materials."

If you want a paper composed entirely of recycled postconsumer waste, such papers do exist. Among manufacturers of fine printing papers, Domtar, Mohawk, Cross Pointe, Monadnock and Crane make papers from 100% recycled materials. (Crane offers papers made from 100% cotton rag and out-of-circulation currency. You'll find more information on cotton papers and other alternatives to papers made from wood later in this chapter.)

Don't overlook industrial-grade papers such as kraft paper, corrugated cardboard and chipboard—all made from 100% recycled paper. Industrial papers are also manufactured to break down more easily in the recycling process and are unbleached. (You'll find out how harmful bleaching paper can be to our environment in the next section.) Most industrial papers aren't suitable for offset printing, but they can be screen printed or letterpress printed.

XX%
TOTAL RECOVERED FIBER
YY% SUBSIDIARY CLAIM

If your project is printed on paper with recycled content and you want others to know, your printer can supply you with art that reveals what percentage of recovered fiber your paper contains. The American Forest and Paper Association has made the logo available to printers through trade associations. For more information, contact them at

1111 19th St., NW
Ste. 800
Washington, DC
20036
(202) 463-2700
Fax: (202) 463-2783.

The Bleaching and Deinking Process

You've spec'd a paper made entirely of recycled paper, and it includes a high percentage of postconsumer waste. As an environmentally minded designer, you're pleased to have

Nicknamed "Mr. Chipboard" by designers who are aware of his penchant for printing on industrial papers, Bruce Licher's pieces are all produced on a letterpress on 100% recycled industrial papers.

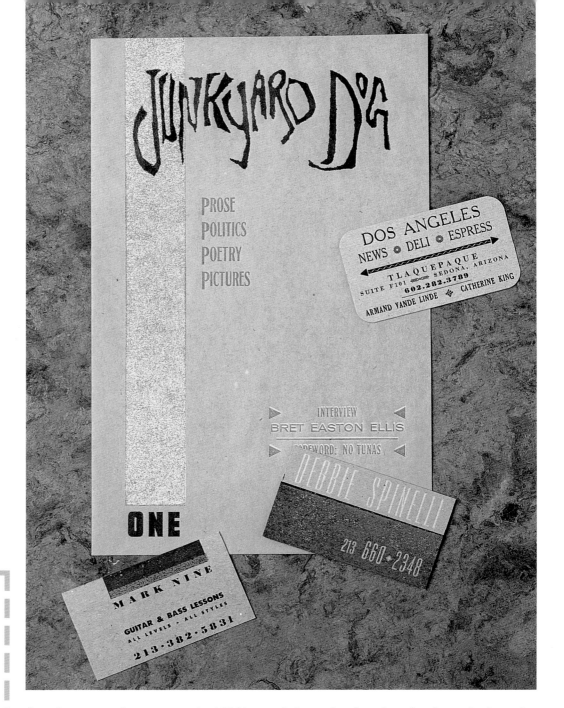

Do Recycled Papers Cost More?

In the late 1980s and early 1990s, most recycled papers cost more than papers made from virgin fiber, but this is no longer the case. Because paper mills have streamlined the manufacturing process, most recycled papers are now comparably priced to non-recycled papers.

found a paper that is not only 100% recycled—its bright white finish rivals that of a 100% virgin fiber stock.

What's wrong with this picture? Unfortunately, it's not enough to spec papers with a high recycled content. The bleaching and deinking process required to make postconsumer scrap comparable to virgin pulp may be just as harmful to the environment as deforestation.

Recycled paper must first be deinked, which results in a toxic sludge that contains the ink, adhesives, dyes, paper clips, staples and other impurities found in consumer scrap. This sludge typically ends up in the landfill, where it can leach into and contaminate groundwater, or in an incinerator, where combusted inks generate airborne pollutants and contaminated ash (which also ends up in the landfill).

More harmful than the sludge produced from deinking is the by-product of the chlorine bleaching process that U.S. mills commonly use to whiten recycled as well as

virgin fiber pulp. This bleaching process produces dioxin, a general term for seventy-five related compounds and an extremely toxic carcinogen that has been linked to reproductive disorders and cancers in fish and animals.

In recent years the EPA has moved to limit dioxin production and disposal in our rivers and streams. In fact, the EPA has set 1998 as a deadline for all U.S. mills to be "nondetectable for dioxin." A few mills have responded to EPA regulations by installing new equipment to bleach pulp with hydrogen peroxide, a cleaner process that's been used in Europe for years. At the time of this writing, the two U.S. mills that use hydrogen peroxide in their manufacturing and bleaching processes are Lyons Falls and Niagra of Wisconsin. Some paper milled in Europe using the hydrogen peroxide process is available in the U.S. market. This includes selected lines from Zanders, Intercontinental and Stora-Papyrus.

Other mills have responded by changing their chlorine-bleaching process to use chlorine dioxide or other chlorine compounds, rather than elemental chlorine. Some papermakers believe this process is less harmful to the environment. U.S. mills offering these papers include Crane, Domtar, Mohawk and Potlatch. These manufacturers refer to their papers as *elemental chlorine free.*

Although the deinking and bleaching processes can be harmful to the environment, experts claim that bleaching virgin fiber requires 75% more bleach than bleaching deinked recycled fiber, meaning that deinked recycled paper is still a more environmentally sound choice than unrecycled paper. A recycled paper that has been deinked may be considered secondarily chlorine free because it is likely made up of papers that were originally bleached.

However, if you're seeking the most environmentally sound commercial printing paper available, a totally recycled, non-deinked paper is your best choice. Believe it or not, printing papers that meet these requirements do exist. You'll find papers offered by Simpson, Domtar, Hopper, Mohawk and Cross Pointe on the chart on page 19. If you need an uncoated paper, these papers are the most environmentally friendly available at the time of this writing. The chart on pages 19–21, listing recycled papers with at least 20% postconsumer waste, shows how other papers stack up against these paper lines.

The EcoLogo is the official mark of Environment Canada. It is awarded to products that meet the country's Environmental Choice criteria. EcoLogo certification for paper requires 50% total recycled content and a minimum of 10% postconsumer fiber. To find recycled papers that meet the requirements for EcoLogo certification, look for this logo on swatch books, or obtain a list of these papers directly from

Environment Canada
107 Sparks St
Second Floor
Ottawa, Ontario
K1A 0H3 Canada
(613) 247-1900.

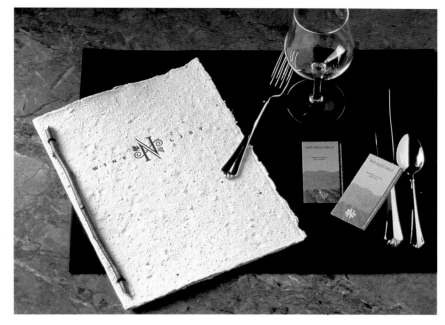

Paper can be made from all kinds of pulp. This wine list cover is made entirely from grape fibers, skins and seeds.

Coated vs. Uncoated Papers

When you check the recycled papers chart on pages 19–21, you'll notice that significantly fewer coated papers are listed than uncoated ones. As a group, recycled coated papers tend to have less recycled content than uncoated varieties have. That's because the slick coated papers typically used for four-color reproduction in magazines and packaging are the most difficult to strip of the impurities that result from adding post-consumer waste to the pulp mix.

Most manufacturers of recycled coated papers refuse to increase the amount of postconsumer waste in their pulp mix because they are afraid that specks or other impurities will appear in their papers. This may seem like a minor consideration, but think how disastrous a black speck would be if it showed up in a model's teeth in a toothpaste ad. Paper manufacturers also charge substantially more for a recycled coated paper—as much as 20% more than for a comparable grade of virgin-fiber coated stock.

In addition to their small percentage of postconsumer waste, recycled coated papers, as well as virgin-fiber coated papers, are harder to recycle because of their clay coating. This coating produces the shiny surface and great ink holdout properties of these papers. It's great for crisp detail and intense color, but its added weight means that recyclers get less fiber per pound for what they recycle. Because the cost of wastepaper is determined by its weight, coated papers are not in high demand from recycling companies and mills.

What's an environmentally concerned designer to do? There are many smooth-surfaced, uncoated recycled papers containing a high level of postconsumer waste that

Sources for Hemp and Kenaf Papers

AMERICAN HEMP MERCANTILE
506 Second Ave., #1520, Seattle, WA 98104, (206) 340-0124, Fax: (206) 340-1086
Sells laser-and offset-compatible hemp paper by mail. Sold by the ream. Offers catalog.

EARTH CARE PAPER
966 Mazzoni Rd., Ukiah, CA 95482, (800) 347-0070, Fax: (707) 468-9486
Sells offset-and laser-compatible hemp and kenaf papers in a variety of sizes. Offers free catalog.

KP PRODUCTS
P.O. Box 20399, Albuquerque, NM 87154-0399, (505) 294-0293, Fax: (505) 294-7040
Offers offset-and laser-compatible kenaf papers in a variety of weights, sizes and finishes. Sold by the ream and by the carton. Will fax product specs.

OHIO HEMPERY
7002 State Route 329, Guysville, OH 45735, (800) BUY-HEMP, (614) 622-6446
Sells letter-sized and larger-sized hemp paper by the ream. Offers free catalog.

TREE CO.
1634 17th St., Santa Monica, CA 90404, (310) 399-TREE, Fax: (310) 399-5303
Laser- and offset-compatible kenaf paper by mail. Sold by the ream. Offers catalog.

TREE FREE ECO PAPER
121 S.W. Salmon, Ste. 1100, Portland, OR 97204, (800) 775-0225, Fax: (503) 233-5430
Offers hemp and kenaf papers that are offset- and laser-compatible in a variety of sizes. Includes writing papers, bonds and even coated sheets. Offers swatches and free catalog.

will suffice for four-color reproduction. However, be mindful that uncoated paper with enough opacity for four-color printing on both sides is thicker than its coated counterpart. This can make a difference in the overall bulk of a magazine or other large publications. Also remember that even the smoothest, highest quality uncoated paper does not perform to the standards of a high-grade coated paper. On uncoated paper, ink is always absorbed into the fibers, so color might seem slightly faded, or type edges may appear slightly blurred.

Tree-Free Papers

Estimates indicate that as much as half of the 12 billion acres of forests that once covered the earth have already been destroyed. Of the trees cut for timber every year in the United States, 40% are turned into pulp for paper and paper products. To help preserve our forests, environmentalists champion the use of papers made from plant fiber as a quick-growing alternative to slow-growing timber. Beyond their environmental worth, papers made from plant fibers are usually stronger and more durable than wood-based papers because the plant fibers tend to be longer than those of wood-based papers.

Cotton is perhaps the best known wood fiber alternative; however, as many as five hundred tree-free possibilities exist, including papers made from such exotic materials as coffee beans, banana peels and seaweed. Some of the more common tree-free alternatives will be explored here.

Papers Made From Kenaf

Forty years ago, in anticipation of a future lumber shortage, the U.S. Department of Agriculture established a research program to develop alternatives to wood-based paper. After extensive research, the agency found kenaf to be one of the most viable alternatives to wood fiber. Kenaf has many advantages over wood pulp. Because it contains less lignin than trees (which gives paper a yellowish cast) kenaf requires fewer chemicals and less energy in the pulpmaking process. It's acid free, making it ideal for archival purposes, and yields more paper per acre than trees.

Kenaf paper can be purchased in the United States from a number of sources (see resources listing on page 14). It's been used for literature by several environmentally minded municipalities in California as well as by *Earth Island Journal*, a forty-eight-page publication printed on kenaf paper. Printers who have worked with kenaf paper say it behaves like a coated paper, offering good ink holdout. Many claim it behaves more consistently on press than some recycled papers.

Kenaf paper costs more—it runs nearly twice the price of wood pulp virgin or recycled stock and 10% to 15% higher

Paper can be made from a variety of non-tree products. Shown are papers made from silk, straw, algae and wheat—all available from Victoria Paper.

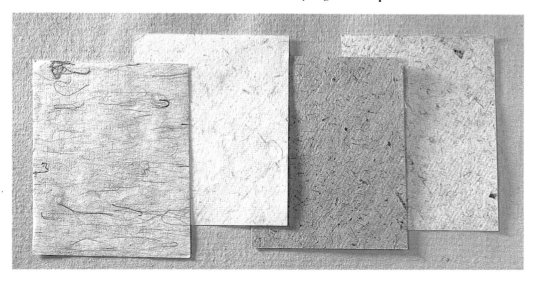

Sources for Tree-Free Papers

CENTRAL ART SUPPLY

62 3rd St., New York, NY 10003, (212) 473-7705, Fax: (212) 475-2542

Carries a wide range of handmade papers (approximately 2,500 kinds) from all over the world, including many made from flowers, grass, fabric and other unusual pulp mixtures. Ask for the paper department. Catalog available.

FOUND STUFF PAPERWORKS

744 G. St., #201, San Diego, CA 92101, (619) 338-7432, Fax: (619) 338-9432

Micro paper mill manufactures paper from hemp and other plants including java and jute. Also produces paper made from 100% junk mail.

GREEN EARTH OFFICE SUPPLY

P.O. Box 719, Redwood Estates, CA 95044, (800) 327-8449,
Fax: (408) 353-1346, e-mail: geo7@ix.netcom.com

Tree-free and other environmentally friendly papers made from hemp and hemp/cotton fiber, coffee beans, etc. Most are laser- and offset-compatible. Available in reams and cases in a range of sizes, including rolls. Catalog available.

LE DESKTOP

P.O. Box 45000, Phoenix, AZ 85064, (800) LE DESKTOP, Fax: (602) 998-1842

Offers laser-compatible papers made from golf course clippings, recycled denim, seaweed and more. Will send sample swatches.

LOOSE ENDS

P.O. Box 20310, Keizer, OR 97307, (503) 390-7457, Fax: (503) 390-4724

Specializes in paper products with a natural, kraft look and heavily textured handmade papers. Also stocks kraft bags, corrugated paper and boxes, natural gift wrap, rafia and other nature-inspired products. Offers free catalog.

VICTORIA PAPER

80-28 Springfield Blvd., Hollis Hills, NY 11427, (718) 740-0990

Offers laser-compatible and handmade papers made from bananas, straw, silk and other exotic materials. Will send sample swatches.

WET PAINT

1684 Grand Ave., St. Paul, MN 55105, (612) 698-6431

Carries handmade and machine-made papers made from straw, hemp and other materials. Over-the-counter sales only.

than premium recycled paper. Part of the high price tag is due to the cost of transporting the paper from the mills where it is produced. The plant is native to Africa and can be grown in only the most southern U.S. states. The mills also impose extra costs for processing the minimum orders of the paper.

However, proponents of kenaf say once investors support the movement and more mills are established, the paper will be cheaper. Some even claim that kenaf could eventually replace tobacco as a cash crop in the South.

Papers Made From Hemp

As a wood substitute, hemp offers many of the advantages of kenaf. It's cleaner to produce than wood pulp, acid free and yields long fibers that produce strong, durable paper. In fact, hemp has an advantage over kenaf in that it can be cultivated over a broader climatic region.

In spite of its many advantages, hemp has not received wide acceptance as a potential papermaking crop because of its association with marijuana. Proponents of hemp say that although the plant was "outlawed" in the 1930s because of its reputation for producing a high when smoked, in fact, the variety of hemp that was grown in the United States for industrial use was not the kind that produces a "good" smoke.

Prior to the 1930s, hemp was one of America's largest cash crops used in the manufacture of canvas, rope and linen as well as paper. In fact, the Declaration of Independence was produced on hemp paper. It has enjoyed a resurgence of popularity in the hands of environmentally concerned businesses and causes seeking wood-free paper alternatives. Greenpeace used hemp paper for bumper stickers, and some Kinko's Copies stores also carry it.

Hemp paper can be purchased from a number of mail-order sources in the United

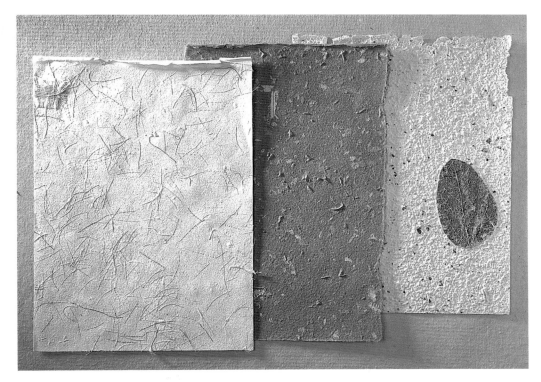

Jerusalem Paperworks can make paper from practically anything, including newspapers, silk and leaves.

States. Because it is illegal to grow hemp in the United States without a permit, most of it is imported from China, making hemp paper, like kenaf paper, quite expensive.

Papers Made From Fabric

According to recent statistics, nearly one million pounds of textile waste are landfilled daily. Wouldn't it be far less wasteful to recycle this textile waste into printing paper?

To some extent, this is already being done. Crane & Company, a New England-based paper manufacturer, has been milling cotton papers since 1801, recycling cotton from used hospital blankets and restaurant linens into paper. Crane offers a number of paper lines with varying amounts of cotton rag content. (The chart on pages 19–21 shows the percentage of postconsumer cotton in each of its lines.) Other paper mills also offer papers with some cotton content.

Paper made from cotton is just as strong and durable as paper made from wood. Its low acidity makes cotton paper particularly suitable for archival use. Cotton writing papers have the look and feel of fine quality art paper. They cost a bit more than other writing papers, but if you're trying to project a look of timeless quality, nothing can compare with a 100% cotton paper. It responds especially well to impact finishing and printing processes such as embossing, engraving and letterpress.

Paper can be made from other fabrics, too. Albuquerque-based Stefan Watson has championed the cause of recycling denim into paper. With the assistance of Crane & Company, Cottrell Paper, and denim scraps from Levi Strauss, Watson has managed to manufacture a nonbleached blue paper that Levi Strauss has used for a variety of purposes, from interoffice mailers to hangtags.

Custom Recycled Papers

Jerusalem Paperworks is one of several small mills that make custom handmade paper from a variety of non-tree products. In business for nearly fifteen years, the mill can add practically anything to its pulp mixture, except metal or animal products. Clients include Des Moines Solid Waste Agency, which had the paper for its annual report cover made from area trash. More exotic inclusions have been flowers, grass and fabric. Processing takes about six to eight weeks. For more information contact Jerusalem Paperworks 5017 S. 24th St. Omaha, NE 68107 (402) 734-1225, Fax: (402) 734-5326

Checklist

@ The most eco-friendly papers are those with the highest postconsumer waste content.

@ Industrial-grade papers such as kraft and chipboard are some of the most environmentally friendly stocks available.

@ Papers with minimal deinking and bleaching are more eco-friendly than their bleached counterparts. If a really white paper is necessary, look for a sheet that is chlorine free or elemental chlorine free.

@ Tree-free papers save trees. Consider using papers made from fabric, hemp and kenaf to help forest conservation if your timetable and budget permit.

Production Considerations

Before recycled papers came into common use, it wasn't unusual to hear about printers balking at the thought of running a job on recycled stock. They complained about inconsistencies and poor performance on press. Some even went so far as to claim that impurities in the paper damaged their equipment.

Printers have varying attitudes toward recycled papers. Some, faced with difficulties on press, look for factors beyond their control. If the paper is labeled "recycled" they may place the blame on the paper rather than looking for other possible causes.

Other printers have made an enthusiastic commitment to recycled papers. The fact is, some brands of recycled papers have been around for many years and perform capably. Most printers today concede that recycled papers perform just as well on press as their virgin-fiber counterparts. However, there are some factors typical of recycled papers that you should be aware of before taking your job to press.

DISCREPENCIES Recycled paper tends to vary slightly from one batch to the next. Imperfections and specks give recycled papers their distinctive character, but if color or flocking consistency is important to maintain, have your printer thoroughly inspect the stock you'll be using before running it through the press. If there are inconsistencies, paper merchants or mill representatives will usually replace your supply at no additional charge.

DOT GAIN Ink tends to spread on uncoated recycled papers, resulting in dot gain of as much as 15%. Halftones should be pinched back to compensate for this spreading.

FOLDING Printers have reported less tendency for cracking to occur when recycled paper is folded against the grain, meaning there is less likelihood that recycled paper will need to be scored at the fold line. This is because the fibers in recycled paper are shorter than the fibers in comparable virgin-fiber papers.

FOUR COLOR Designers who have worked with four-color reproductions on uncoated stock suggest beefing up the color to compensate for the paper's less reflective surface. Adding fluorescent ink (fluorescent red to process magenta, fluorescent yellow to process yellow, etc.) increases color vibrancy and the opacity of the ink. Soy- and vegetable-based inks also perform well on uncoated stock. (For more information on these inks, see chapter two.) Some designers have found the color obtained in waterless printing, or dryography, is more vibrant on an uncoated sheet than what can be obtained with traditional offset. (For more information on dryography see chapter four.)

HALFTONES Most paper manufacturers recommend a 133-line screen for printing on uncoated recycled papers. To compensate for dot gain, shadows and midtone areas should be pinched back.

PICKING AND LINTING Picking, or linting, occurs when the tack of the ink pulls the short or loose fibers off the surface of the sheet. Your printer can guard against this by first running the stock through the press without ink or water. Slowing the press down or increasing the blanket pressure also helps to alleviate the problem. If printing is just on one side of the sheet, printing on the wire side of the paper may also help (papermakers claim that fibers on the wire side of the sheet are more tightly bonded).

UNEVEN SOLIDS When printing on uncoated recycled paper, achieving dense solid areas of color larger than 4" x 5" often requires more than one hit of ink. Paper manufacturers recommend running a 40% screen of color beneath solid ink coverage or printing two hits of the same color. If printing on just one side of the sheet, printing on

the wire side as opposed to the felt side of the paper also helps.

Finally, as for any job in which perfection is critical, you may want to request a *draw down*, a sample of inks specified for the job printed on your paper of choice, from your printer in order to test a sample of the recycled stock you'd like to use on press.

Top Seven Recycled Papers: Chlorine Free With Minimal De-inking

Paper	Post-consumer Waste	Non-deinked Fiber	Non-chlorine Bleached	Chlorine Free
Cross Pointe Genesis	100%		*	
Domtar Sandpiper	100%	*	*	
Domtar 100% Recycled	100%	*	*	
Klippan Fridaflack	100%	*		
Mohawk Vellum P/C 100	100%	*		*
Simpson Quest	100%	*		*
Hopper Proterra	80%	*		*

Recycled Content of Common Mill Papers

Information is limited to U.S. mills. All information in this chart was supplied by the manufacturers. Unless otherwise specified, percentages are based on white paper.

Manufacturer/Line	Pre-consumer Waste (%)	Post-consumer Waste (%)	Total % Recycled
COATED PAPER			
Ahlstrom Paper Corp. of Amer.			
Masterart R/C	40	10	50
Champion			
All-Purpose Litho Recycled	40	10	50
Kromekote Recycled	40	10	50
Domtar			
Cornwall Coated Cover	20	20	40
Future Fiberes Group Inc.			
Sav-A-Source			
Premium	40	10	50
Quality	90	10	100
James River			
RetreeveCoat	20	30	50
Silhouette Cast Coated	20		20
TuscanCoat	20	30	50

CONTINUED IN NEXT COLUMN

Manufacturer/Line	Pre-consumer Waste (%)	Post-consumer Waste (%)	Total % Recycled
COATED PAPER, CONTINUED			
Mohawk			
50/10 Matte/Gloss		15	15
RePap Enterprises			
Excellence	40	10	50
Lithoweb	40	10	50
Lithofect PLUS	30	20	50
Multifect	40	10	50
Multiweb	40	10	50
Repap Matte Web	40	10	50
Repap Matte	30	20	50
Riverside			
Ecology Bond Offset	90	10	100
Simpson			
EverGreen	25	25	50
S.D. Warren			
Lustro Recycled	40	10	50
Recovery Gloss	40	10	50
Westvaco			
American Eagle Web Offset	40	10	50
Celesta		10	10
Citation-PC		10	10
Marva Deluxe-PC		10	10
Printkote Eagle		10	10
Sterling-PC		10	10
Weyerhaeuser			
Choctaw "10" Recycled		10	10

CONTINUED ON NEXT PAGE

Manufacturer/Line	Pre-consumer Waste (%)	Post-consumer Waste (%)	Total % Recycled
UNCOATED PAPER			
Beckett			
Cambric	30	20	50
Concept	30	20	50
Enhance	30	20	50
Expression	30	20	50
RSVP	30	20	50
Ridge	30	20	50
Champion			
Benefit (25% PC)	75	25	100
Benefit (75% PC)	25	75	100
Champion Carnival	30	20	50
Mystique Laid	30	20	50
Crane & Co., Inc.			
Cranes Crest R	30	20	50
Cranes Old Money			
Greenback	30	70	100
Mint	70	30	100
Weston Sav-A-Source	30	20	50
Whisper	30	20	50
Cross Pointe			
Aquarius		20	20
CP Recycled Bond	30	20	50
Genesis		100	100
Halopaque	80	20	100
Passport	30	20	50
Synergy	30	20	50
Domtar Inc.			
Byronic	60	10	70
Concerto 1000	70	10	80
Cornwall Book	20	20	40
Naturals			
Kraft	10	45	55
Jute	15	45	60
Wicker	65	35	100
Silk, Plaster, Glass	20	35	55
Brass, Reed	35	20	55
Corrugate	20	45	65
Brick	60	40	100
Sandpiper		100	100
Finch, Pruyn & Company, Inc.			
Finch Casablanca Opaque		20	20

CONTINUED IN NEXT COLUMN

Manufacturer/Line	Pre-consumer Waste (%)	Post-consumer Waste (%)	Total % Recycled
UNCOATED PAPER, CONTINUED			
Fox River			
Circa '83	30	20	50
Circa Select	30	20	50
Confetti	50	50	100
Early American	25	25	50
Fox River			
Bond & Cover Recycled	70	30	100
French Paper Co.			
Dur-O-Tone	75	25	100
Construction	80	20	100
Rayon	60	20	80
Speckletone	60	20	80
George Whiting			
Brockway	90	10	100
Brockway Plus	90	10	100
Cadence	90	10	100
Coat of Arms Cover	90	10	100
Crestline Offset	90	10	100
Ultima	90	10	100
Gilbert			
Correspond	55	20	75
Cover Recycled	55	20	75
Esse	40	20	60
Gilcrest Recycled	30	30	60
Manuscript	30	30	60
Neutech Recycled	55	20	75
Oxford	30	30	60
Union Watermark Recycled	55	20	75
Hammermill			
Accent Opaque Recycled		20	20
Brite Hue	30	20	50
Fore DP Colors		20	20
Hammermill			
Text/Cover/Linen	30	20	50
Writing/Bond		20	20
Savings DP		20	20
Unity Offset/DP	50	50	100
Howard			
Capitol Bond	30	20	50
Crushed Leaf	25	25	50
Howard Bond	30	20	50
Howard Linen	30	20	50
Howard Text & Cover	30	20	50

CONTINUED ON NEXT PAGE

Manufacturer/Line	Pre-consumer Waste (%)	Post-consumer Waste (%)	Total % Recycled
UNCOATED PAPER, CONTINUED			
James River			
Curtis Brightwater			
Recycled Riblaid	30	30	60
Curtis Linen	40	10	50
Curtis Marble	40	10	50
Curtis Retreeve	50	10	60
Curtis Tuscan Antique	50	10	60
Curtis Tuscan Terra	50	10	60
Curtis Tweedweave	40	10	50
Graphica			
Felt/Lineal/Vellum	40	10	50
Flocked	25	25	50
100	40	60	100
Riegel PCW Cover	50	20	70
Keith Clark, Inc.			
Diamond White Recycled	85	15	100
Mohawk			
Irish Linen		25	25
Mohawk Opaque (Fibered)		25	25
Mohawk Satin		25	25
Mohawk Vellum P/C100		100	100
Mohawk Vellum Colors		25	25
Monadnock			
Revue Recycled	40	20	60
Revue PC 100		100	100
Neenah			
Classic Laid	30	30	60
Classic Crest	30	30	60
Environment	85	15	100

CONTINUED IN NEXT COLUMN

Manufacturer/Line	Pre-consumer Waste (%)	Post-consumer Waste (%)	Total % Recycled
UNCOATED PAPER, CONTINUED			
Nekoosa			
Ardor	35-40	10-15	45-55
Patriot Paper Corp.			
Patriot	90	10	100
Simpson Paper			
Coronado SST Recycled	30	20	50
Ecopaque	30	20	50
Equinox	50	50	100
EverGreen Script	30	20	50
Gainsborough	30	20	50
Quest		100	100
Sundance	30-80*	20	50-100
Strathmore			
Elements	20	30	50
Grandee		20-50	20-50
Strathmore Bond	25	25	50
Strathmore Renewal	25	25	50
Ward			
Lake Shore	30	20	50
Cimarron	25	25	50
Westvaco			
American Eagle Web Offset			
Bulking Offset and Envelope			
Wove	40	10	50

*depends on color

Using Inks Responsibly

Picking an environmentally friendly paper is just the first step in producing an environmentally sound printed piece. It's necessary to use inks that are environmentally friendly, as well.

In this chapter you'll find out what your ink options are, which ones are good for our planet and which ones are harmful. You'll also learn about how they perform on press and on recycled papers.

Petroleum-Based Inks

Printing inks are made up of pigment, a vehicle (the liquid that carries the pigment), and additives that help the drying and binding process. In conventional inks, pigments are suspended in petroleum. However, petroleum-based inks and alcohol, the solvent of choice for these inks, contribute to air and water pollution. As alcohol and petroleum evaporate, substances called *volatile organic compounds* (VOCs) are released. In addition to creating an environmental hazard, VOCs present a health hazard to pressroom workers.

The federal government has placed restrictions on print shop VOC emissions. In some parts of the country, state and local restrictions apply. In southern California print shops must monitor VOC emissions daily. Because alcohol-based press washes also emit VOCs, some print shops have reduced VOC emissions by using citric-based rather than alcohol-based press washes.

If you are interested in minimizing VOC pollution, work with a print shop that is conscientious about its VOC policy. If you're not sure about your printer's commitment to clean processes, ask. Most printers are well aware of the issue and of non-VOC alternative inks (covered in the next section). If you're looking for the most environmentally friendly inks, avoid petroleum-based inks altogether and ask your printer to use soy- and vegetable-based inks.

Soy-Based and Vegetable-Based Inks

During the oil embargo of the 1970s, many print shops and newspaper publishers searched for an alternative to their petroleum-based inks. Inks made from vegetable oils, particularly soybean oil, were found to be an economical replacement with comparable quality.

Vegetable-based and soy-based inks are also better for the environment. They break down more readily in the landfill as well as in the deinking and repulping processes, and because they are more soluble than petroleum-based inks, they require less cleanup time and fewer cleaning agents. They also emit fewer VOCs. When petroleum inks dry they emit 25% to 40% VOCs, whereas soy- and vegetable-based inks emit as little as 2% to 4%.

Vegetable inks can be made from corn, walnut and coconut oils. (In Canada, canola has become the ink vehicle of choice, whereas in the United States soybean oil has dominated the market.) As a renewable resource, soy- and vegetable-based inks conserve our limited supply of petroleum. Using soy- and vegetable-based inks supports U.S. farmers. Brand names for these inks include Agri-Tek, Bio-Tech, EcoPure and Ecoprint.

Some inks, even though they have soy or vegetable content, include petroleum in their formulation. In fact, some brands labeled "soy ink" may actually contain more petroleum than soy oil. Printers may differentiate between these inks with terminology such as *no-VOC*, *reduced VOC* or *low-VOC*. To ensure you are using a low-VOC ink, ask your printer what the VOC rating of the ink is according to EPA Method 24. This test is most often used to measure VOC levels and produces a rating comparable to the percentage of its petroleum content. Again, look for a low VOC rating of 2% to 4%.

In addition to their environmental worthiness, soy and vegetable inks offer other advantages—especially when working on recycled, uncoated papers. Because vegetable oil is clearer than petroleum oil, vegetable-based inks produce vivid color. Soy and

Recycled Inks

Waste inks must be considered toxic waste since the pigment bases of vegetable-, soy- and petroleum-based inks contain toxic elements. Conscientious printers who are aware of this are recycling waste inks into new inks.

New York City-based Superior Inks has taken measures to reduce the ink disposed of in our waste streams or incinerated. The company collects waste inks from the press fountains of local printers as well as obsolete printer's ink inventory. Superior then uses these inks in the formulation of new ink.

Designers interested in using recycled inks on their printed projects should have their printer contact Superior and request Recync inks. Contact Superior Inks at (212) 741-3600.

vegetable inks are also less absorbent, reducing dot gain on press, and tend to rub off less than petroleum-based inks.

These inks sound too good to be true, right? Their only drawback is their drying time. Soy and vegetable inks usually require additional drying time (how much more than petroleum-based inks varies, depending on the paper and humidity level). They also cost a bit more than petroleum-based inks, on the average 10%. However, black soy ink costs close to 25% more than its petroleum counterpart because it is composed of approximately 50% oil. It's estimated that nearly 25% of U.S. commercial printers currently use soy-based inks.

Toxic Colors

Whether they are vegetable based or petroleum based, some of the pigments that go into printing ink contain metallic substances that are suspected to be harmful to the environment. These metallic substances eventually enter landfills in deinking sludge and leach through to the water table. Although EPA researchers have not yet determined what level these compounds must reach before they are considered harmful, some environmentalists believe they do have the potential to harm plant and animal life as well as to cause health problems in humans when ingested, inhaled or absorbed. However, some experts doubt that these substances are harmful when they exist in such small quantities in inks.

Over the years many metallic pigments that are known carcinogens, such as lead, chromium and cadmium, have been replaced with carbon-based substitutes. However, some compounds that continue to be used in the formulations for certain colors have aroused suspicion. They include the barium compounds used to make Pantone warm red as well as other pigments that contain high levels of copper and zinc.

A number of Pantone metallic colors fall into this category and are on the federal government's Section 313 list. Issued in 1987, this list is officially titled as Section 313 of Title III of the Superfund Admendments and Reauthorization Act (SARA). Revised in 1991, this list identifies ink colors containing compounds that could be harmful. Four fluorescent colors are also on the list because they contain dyes that are suspected carcinogens. The chart on page 25 lists the Pantone colors on the Section 313 list.

Designers who want to can avoid all colors on the Section 313 list, or in some cases, pick an alternative. Pantone has come up with a barium-free substitute for warm red that combines Pantone yellow 012 with red 032. Some ink manufacturers have also developed safer formulations. For instance, Ecoprint in Silver Spring, Maryland, produces vegetable inks with extremely small traces of the Section 313 compounds. The inks are slightly more expensive, but they perform admirably on press. Superior Ink also offers barium-free substitutes for the Pantone colors on the Section 313 list.

Section 313-Listed Pantone Colors Containing Zinc and Copper

Color by PMS No.	Copper	Zinc	Color by PMS No.	Copper	Zinc
8001	9	1	8740	28	3
8002	20	2	8741	22	2
8003	25	2	8742	22	2
8004	30	3	8760	22	2
8005	38	4	8762	22	2
8521	28	3	8780	22	2
8540	33	3	8781	22	2
8560	28	3	8800	22	2
8561	28	3	8801	22	2
8580	38	4	8820	28	3
8581	33	3	8821	22	2
8582	28	3	8822	22	2
8600	33	3	8840	28	3
8601	28	3	8841	22	2
8640	33	3	8860	28	3
8641	28	3	8861	28	3
8660	33	3	8862	22	2
8661	22	2	8881	28	3
8662	22	2	8882	22	2
8680	33	3	8900	28	3
8681	28	3	8901	22	2
8682	22	2	8902	22	2
8700	33	3	8921	22	2
8701	28	3	8941	28	3
8702	22	2	8942	22	2
8720	28	3	8961	28	3
8721	28	3			
8722	22	2			

*percent of total pigment by weight

Less is More

Because paper must be deinked before the pulp can be recycled into new paper, keeping ink coverage to a minimum is always better for the environment than covering the entire sheet with color. Full-bleed color may be unavoidable in some situations, but if at all possible, think "spare" when considering the ink coverage in a design concept.

Section 313-Listed Pantone Colors Containing Barium

(COLOR RANGE BY PMS NO.)

123-126	436-440
136-140	443-447
1365-1405	455-457
150-154	4625-4645
1555-1615	469-472
163-168	490-495
1625-1685	497-501
170-175	4975-5005
176-181	504-509
1765-1815	5185-5215
183-188	5535-5565
189-195	560-565
211-216	567-572

Eliminating Wasteful Design

This chapter discusses how to conserve energy and materials. You'll find out how to design projects that make economical use of paper by taking advantage of standard sheet sizes. You'll also learn how to eliminate unnecessary processes and materials in prepress production.

You'll also find out what goes into designing an environmentally sound packaging concept and find tips on how to avoid overpackaging a product. You'll learn about eco-friendly packaging materials and the most environmentally kind techniques for printing and constructing a container.

Eliminate Unnecessary Prepress

Think "efficiency" when producing mechanicals, and try to minimize material output and wasted effort. When working on the computer, produce as much as possible digitally and try to proof as frequently as you can on screen. If possible, send files for client approval by modem or on disk to avoid unnecessary printing of laser proofs.

If you're not already doing this, go directly to film with your computer files. You'll find that eliminating high-resolution output on resin-coated paper saves paper, time and money. Placing photos and other images into your digital files saves stripping costs and materials. Use image scans and photo CDs as often as possible and reserve professional scanning of images for situations that warrant critical color and detail reproduction.

You can save additional time and resources by eliminating the film stage and going directly to plate with your job. Printers (especially those involved in publishing) are beginning to realize the economies involved in skipping the film stage and are incorporating filmless prepress into their production. Filmless printing has taken hold in many European countries and is used by many newspaper printers in the United States, since quick turnaround has great payoff. Many offset lithographers are beginning to provide filmless prepress for clients who have enough computer savvy to trust their digital mechanicals. So if you're ready to commit to this option, you will save resources and also eliminate the toxic chemicals involved in film developing.

Don't Waste Paper

If you've ever thought of designing an odd-sized brochure or other printed piece, think again. An 8½" x 11" or 11" x 17" piece fits nicely on an 11" x 17" sheet, but when you get into odd-sized projects and larger sheets of paper, it's important to determine how your project will be impositioned on the entire sheet.

Let's say you've designed a five-panel brochure that will accordion fold to fit into a number 10 envelope. Measuring 8½" x 18⅜", the brochure folds neatly down to an 8½" x 3⅝" size. What's wrong with this concept? A lot of wasted paper. Because paper comes in standard sheet sizes, an incredible amount of paper will be wasted when this brochure is trimmed to its final size. The illustration on the next page shows just how much you waste when producing a brochure with these dimensions—a 4½" x 17½" portion of each sheet. This may not seem like a lot, but in a run of just one thousand, it amounts to a sizeable amount of wasted paper. Designers who come up with concepts that waste paper eventually hear about it, because nobody likes to pay for something they don't get. Needless to say, the environment pays as well, in wasted paper that could be more efficiently put to use on press.

Remember that the U.S. and Canadian printing industries revolve around the 8½" x 11" sheet, so use sizes that fit within or are multiples of 8½" x 11". For a project that is exactly 8½" x 11", such as a letterhead, a bleed requires a larger sheet to accommodate the trim area on the bleed. This may not result in much discarded trim with a large run, where letterheads can be printed four-up on a larger-sized sheet, but it can account for a lot of wasted paper or unnecessary setup time for a small run of one thousand.

If your piece is an unusual size, do a diagram of how several copies will fit onto a larger sheet. The diagram on page 28 shows some typical impositioning layouts of projects on a 23" x 35" sheet.

Paper-Saving Publications

When printing a magazine, catalog or other high-volume, multipage publication, consider switching from the standard 8½" x 11" format to 8" x 11". The smaller size allows more pages to be impositioned on the paper, resulting in less waste. On large quantities the cost savings can amount to hundreds, even thousands, of dollars, not to mention vast quantities of paper.

Four 4-page 8½" x 11" brochures

Two 17" x 22" posters

Four 8-panel 4" x 11" brochures

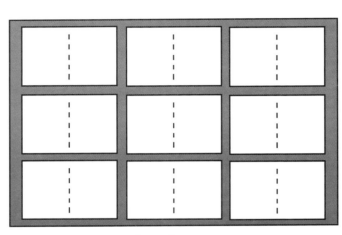

Nine 4½" x 6½" greeting cards

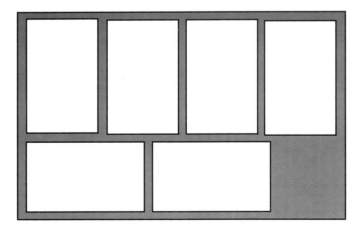

Six 8½" x 14" flyers

Two 9" x 12" pocket folders

Using paper efficiently depends on how well you understand how a piece will fit when printed on standard sheet sizes. Shaded areas on the above diagram represent wasted trim.

This resealable bag for Mariani dried fruits epitomizes economical, environmentally sound packaging. It stands up on its own, eliminating an outer carton, and its resealable top encourages consumers to reuse it.

What if your client or firm wants you to produce a job that results in wasted trim? Seize the moment and print another project on it. Many designers capitalize on such an opportunity by ganging their own work or jobs for other clients on wasted trim. This type of initiative not only saves resources, it saves money.

Create Responsible Packaging

It would be nice if coming up with an environmentally sound package design were just a matter of specing a container made from recycled paper and printing it with vegetable-based inks. Although using recycled materials and safe inks is important, you should take into account how a package impacts our environment from production to disposal.

Will a Granola Look Sell?

When designing with industrial stocks, designers need to weigh the merits of using 100% recycled stock against the package's shelf appeal. Will a brown, chipboard box have enough shelf presence to stand out from its competitors? Will a food product printed on its surface appear as appetizing as it would printed on a bleached, white surface?

Fortunately, many manufacturers realize that consumers want to buy products in environmentally responsible packaging and are asking designers to use environmentally kind materials. In other words, savvy consumers may go for the product wrapped in brown kraft paper, just because they prefer to support a manufacturer that packages its products in environmentally friendly materials.

Reduce the Size

One of the simplest package design axioms to follow is *make it small.* It's fairly obvious that overpackaging an item for display purposes wastes resources. Source reduction is always the first and most important factor in packaging design.

The evolution of audio compact disc packaging is a good example of how a package can be streamlined to conserve resources. Initially, compact discs came packaged in what the recording industry called the "long box." The long box was twice the size of the compact disc it encased, but music industry retailers insisted it was necessary to fit store fixturing that had been designed to accommodate LP albums. Recording artists were reluctant to package their compact discs in anything smaller than the long box, fearing a smaller package would have poor shelf visibility. Sting introduced a smaller box in his release of *Soul Cages* in 1991. *Soul Cages'* success, in spite of its compact packaging, encouraged other recording artists to follow Sting's example, refusing to package their releases in the long box. Now, almost all compact discs are packaged in the compact "jewel cases" that have become the industry standard.

Designer Primo Angeli, whose firm designed award-winning packaging for Miller Brewing, Nestle and Zima, feels that economical packaging, such as his firm's design for Mariani dried fruit, has come about to some extent in response to consumer demand for less waste in packaging. "Consumers are looking at items that are overpackaged and feeling, 'There's something wrong here,' " observes Angeli. "If that feeling persists, it inhibits purchase."

In other applications, designers have found they can reduce the size of a package by printing instructions, warranty information and other copy on a paper insert rather than on the outside of the package. Informational point-of-purchase displays can also supplement copy that formerly appeared on a package's exterior.

If clients can overcome the idea that bigger is better, selling a concentrated version of the product will also reduce the packaging involved. Eco-conscious designers can suggest these alternatives when trying to conceive of a way to reduce a package's size. Source reduction is also achieved when outer packaging is eliminated; e.g., stand-up tubes of toothpaste that don't require an outer box.

Make It Reusable

Because reusable containers won't end up in the landfill as quickly as throwaways, packaging with an afterlife is far more desirable than a container that will immediately be pitched. An empty package can be reused if it can be resealed and is durable enough

Sources for Eco-Friendly Packaging Alternatives

AIR PACKAGING TECHNOLOGIES
25620 Rye Canyon Rd., Valencia, CA 91355, (805) 294-2222, Fax: (805) 294-0947
Manufactures Air Box, an air cushion that conforms to the shape of a product, surrounding it and cushioning it against impact.

GENPACK USA, INC.
8300 Boettner Rd., P.O. Box 35, Bridgewater, MI 48115, (800) 742-7225, Fax: (313) 429-4714
Manufactures 85% paperboard packets printed with soy-based inks and water-soluble varnishes. Appropriate for single or multidose applications of liquids, creams, pills and powders.

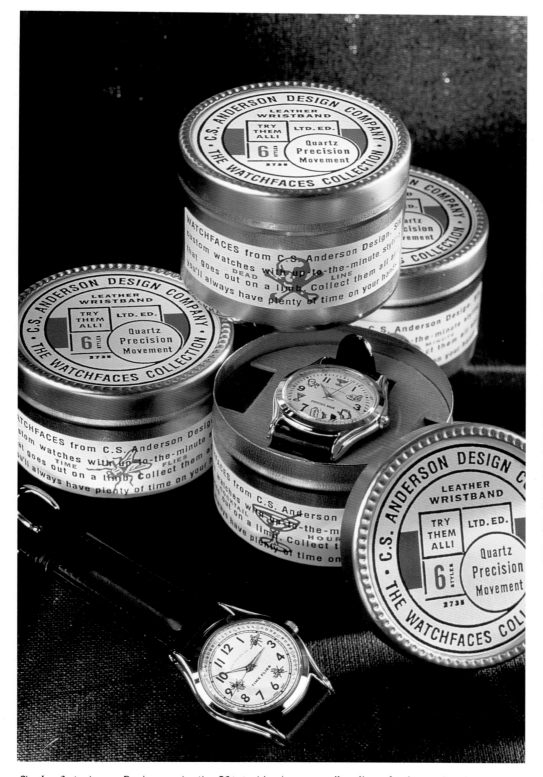

Inks and Other Finishes

When producing packages on paper and paperboard, follow these guidelines:

@ If possible, stipulate vegetable- and soy-based inks.

@ Specify nontoxic inks or inks that are labeled "Toy Safe." (See table on page 25 for a list of toxic ink colors to avoid.)

@ To allow for easy package recycling, keep ink coverage to a minimum so the paper can be easily deinked. Avoid plastic laminates, varnishes and other coatings that may impede the deinking process.

Charles S. Anderson Design, under the CSA Archive banner, sells a line of wristwatches in tins. The tins' archival look gives them instant status as keepsakes, and their handy size and snap-on lids encourage reuse as storage for jewelry and other small items.

to hold up to repeated use. Product packaging utilizing this principle includes resealable plastic bags for packaging dried fruit, nuts and other foods, cloth tote bags for shoes and accessories, refillable containers for detergents and household cleaners, and snap-lock lids on containers for food and soft goods. If all products came in reusable containers, think of how substantially our landfills would be reduced.

When designing a reusable container, remember that a reusable and resealable container should not only be sturdy and functional, but it also needs the visual appeal of a keepsake for a consumer to want to keep and reuse it.

Choose Materials Wisely

Whether a package will be thrown away or reused, it is more environmentally friendly if it is made from (1) a recycled material, (2) a material that requires a minimum of waste in its manufacture, or (3) a material that biodegrades rapidly and without harm to the environment.

When specing recycled materials, obvious choices in environmentally friendly paper and paperboard packaging include recycled and unbleached papers and industrial stocks such as corrugated cardboard, chipboard and kraft paper. Industrial stocks are made from 100% recycled paper, they are easy to recycle, and they biodegrade easily. Avoid clay-coated paper, plastic laminates, and other processes that inhibit the recyclability or biodegradability of the container.

Other materials commonly used in packaging are plastic, aluminum, glass and steel. The Tellus Institute, a nonprofit environmental research and consulting group that counts the EPA among its clients, has determined that producing these packaging materials has a greater impact on our environment than their disposal. The group rated packaging materials with a method of analysis called *Life-Cycle Assessments* (LCA). LCA determines how these materials impact the quality of our water and air from manufacture to disposal.

The Tellus Institute (not surprisingly) found that recycled counterparts for glass, aluminum, steel, boxboard and paper have less environmental impact than their virgin counterparts. The group also found that, on a per-ton basis, glass has the least environmental impact, followed by paper, steel and recycled aluminum.

Plastics and virgin aluminum have the most environmental impact. Plastic is made from petroleum, a nonrenewable resource. The manufacture of plastics also generates air and water pollutants. Mining bauxite, which is used in the production of aluminum, produces a corrosive "red mud" that can pollute surface water and groundwater. Aluminum is also the most energy intensive of the major metals to produce.

The Tellus Institute also found the weight of packaging affects its environmental impact. Therefore, the polystyrene, plastic clamshells that fast-food chains use for packaging burgers have less environmental impact than their heavy, paperboard counterparts that, at one point, were thought to be more desirable because they were more biodegradable and recyclable. (Actually, the most environmentally friendly option would be to wrap burgers in recycled paper.)

Although the Tellus Institute's findings are useful, they are not official. The Tellus Institute and similar organizations have come under fire from the EPA, which is also studying the cradle-to-grave environmental impact of packaging materials. However, until the EPA releases its findings, most food industry officials will continue to use the Tellus Institute's findings to guide their packaging strategies.

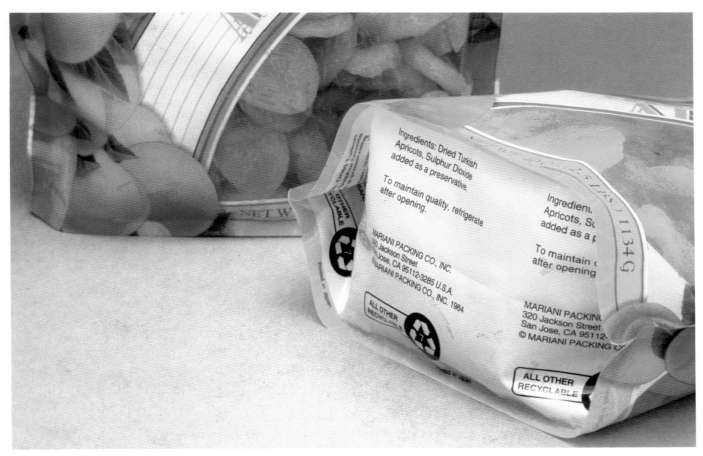

Do Plastics Have an Impact?

Plastic has had remarkable success as a packaging material. Used in a variety of applications, plastic can be resilient, lightweight, sterile and even bulletproof.

Industry experts estimate that close to 60 billion pounds of plastic are produced each year, with 15 billion pounds produced for packaging.

Problems occur when plastic ends up in our waste streams and landfills. It has been estimated that more than 80% of the trash floating in the Pacific Ocean is plastic, affecting sea birds and marine life. Discarded plastic accounts for 8% of the weight and 20% of the volume in our landfills. Although the proportion of plastic in our landfills may not seem large, its lack of biodegradability has significant impact.

Recently, the Society of Plastics Industry (SPI) developed a numerical coding system to guide consumers and encourage them to recycle plastic containers. The numbering system rates plastic recyclability from 1 through 7; however, only #1 PET, PETE plastic (mostly used for soft drink bottles) and possibly #2 HDPE plastic (mostly used for milk, juice and water bottles) are accepted by recycling centers. Environmentally minded consumers have taken the SPI to task over this coding system, which they say is misleading in its coding of nonrecyclable plastics rated #4 through #7. Until the coding system is revised, designers wanting to incorporate recyclable plastics into their container designs should specify #1 PET, PETE and #2 HDPE plastics.

The plastics industry has developed a numerical coding system that guides consumers on how to recycle plastic containers. Their numbering system rates plastic recyclability from 1 through 7.

Printing and Finishing Processes

Producing eco-friendly printed materials depends a lot on the type of printing and finishing techniques used on the job. Some printing methods tax environmental resources less and pollute less than others. Finishes, such as varnishes, can be easy or hard to remove from paper when it is recycled, depending on what type is used.

This chapter gives you the information you need to select printing and finishing techniques that are least harmful to the environment. You'll also learn how to make sound judgments when it comes to selecting an environmentally responsible printer by knowing what kinds of eco-friendly shop practices to look for.

Offset Lithography

As the most frequently used printing method, lithography uses film negatives (made digitally, or photographically from a mechanical) and chemically treated plates. The inked image on the metal plate is then "offset" or printed onto a rubber blanket and transferred onto paper.

The chemicals involved in etching plates and making negatives have a negative impact on the environment. Film is manufactured with silver halides and plastics. The developing process uses toxic substances such as bleach and sodium thiosulfate. The polyester plates used in short-run print jobs usually end up in the trash, and their ultimate burning in an incinerator causes toxic pollution.

Although chemical recycling and recent federal regulations have significantly reduced environmental pollution from photographic processes, disposal of some waste products remains a problem. Unfortunately, most print shops don't take the time to recycle or properly dispose of materials used in press makeready. Aluminum plates can be recycled easily. The plastic film used to make negatives can be recycled also if the negatives are first stripped of silver.

Once plates have been made, the degree of environmental friendliness involved in the process depends on the inks used on press and the solvents used as press washes. Low VOC soy- and vegetable-based inks have the least impact on the environment, whereas petroleum-based inks have a negative impact. Petroleum-based inks containing toxic pigments are most harmful to the environment. The alcohol-based solvents used for cleaning petroleum-based inks also have a high level of toxicity; citric-based press washes are less toxic. (See chapter two for more information on inks and their environmental toxicity.)

To find out if your printer uses environmentally sound practices, ask how toxic materials are disposed of. In addition to paper, are inks, film, plates and other materials recycled? Ecologically aware printers also monitor and maintain low levels of toxic, VOC emissions in their shop.

Laser Printing

Laser printers use dry powder toners, consisting of plastic polymers, that are applied to paper with electrostatic charges. Heat fixing fuses these plastic polymers once they have been applied. Because these plastic particles have become bonded to the paper fiber, laser-printed paper is extremely difficult to deink. Recyclers claim that ink specks from these papers almost inevitably make their way to the finished paper, in fact, some will buy only "laser free" waste.

Dryography

A printing process that has been used extensively in Japan over the past twenty years, dryography, or waterless printing, is quickly becoming the choice of U.S. designers seeking an environmentally friendly alternative to offset lithography. As with offset printing, low VOC soy- and vegetable-based inks and citric press washes can be used with dryography to make the printing process even more eco-friendly.

Dryography is especially effective for printing four-color images on uncoated

Recycling Photo-processing Chemicals

Agfa, a manufacturer of products and equipment used in the negative and platemaking process, recently introduced a recycling program called Planet Agfa that should help minimize the waste and pollution that press makeready generates. Agfa customers who accumulate more than four thousand pounds of makeready waste per year can have their photoprocessing chemicals picked up at the workplace for silver reclamation. Agfa also supplies its customers with containment bins for used polyester plates and arranges for pickup and shipment of the filled bins to a local recycling plant where the plates can be recycled into lower-grade polyester products.

Dryography Printers

BERMAN PRINTING
1441 Western Ave., Cincinnati, OH 45214, (513) 421-1600

THE BRADLEY PRINTING CO.
2170 S. Mannheim Rd., Des Plaines, IL 60018, (708) 635-8000

GRITZ RITTER GRAPHICS
5595 Arapahoe Rd., Boulder, CO 80303, (303) 449-3840

HARRIS SPECIALTY LITHOGRAPHERS INC.
1519 Stone Ridge Dr., Stone Mountain, GA 30083, (404) 938-7650

LITHO SPECIALTIES INC.
1280 Energy Park Dr., St. Paul, MN 55108, (612) 644-3000

NATIONAL PRINTING & PACKAGING CORP.
3800 Quentin St., Denver, CO 80239, (303) 371-3777

SECOND NATURE GRAPHICS
1 Entin Rd., Clifton, NJ 07014, (800) 969-8901, (201) 779-8900

paper. In offset lithography, alcohol and water are absorbed into the paper, causing a dull, soft image. Because dryography uses no water, the ink stays on the top of the paper. As a result, uncoated paper takes on the holdout properties of a coated sheet—images are crisper and have greater color brilliancy than they normally would on an uncoated sheet. Because there are a greater number of uncoated papers with high recycled content, dryography can achieve effective results with four-color on these sheets.

Because it performs so well on uncoated paper, dryography is frequently used for reproducing art prints that are printed on uncoated archival paper made from 100% cotton. The negative and platemaking processes also make it easier to produce negatives with a high 300 to 400 lpi, making it possible to reproduce fine detail with excellent results.

Dryography can be used on the same types of paper normally used for offset printing. It usually costs 10% to 20% more than conventional printing, and it can be used on both sheetfed and web jobs.

Letterpress

This classic printing technique was the most-used method of printing in Western technology until photographs came into use in publishing in the twentieth century and offset lithography began to dominate the printing industry.

Letterpress uses a photoengraved plate or metal type that hits the paper surface and imbeds the ink into the pulp fibers. Using the hand-set type with which letterpresses are equipped saves materials and resources because it eliminates the need for burning offset plates and developing film negatives. The lead type used in the process can also be completely recycled—printers simply melt it down so it can be used to form type for another project. Letterpress printers also point out that because the process generates impressions at a slower pace, less paper is wasted during a run.

Because the process leaves a smooth impression that contrasts nicely with soft uncoated paper, letterpress can be used on uncoated papers with a high recycled content. It also can be used to print on surfaces not suitable for offset lithography, such as handmade and industrial-grade papers. Boasting 100% recycled content, industrial papers break down more easily in the recycling process than other papers. They include kraft, chipboard and packaging materials.

Like offset, letterpress printing can be done with vegetable- and soy-based inks as well as petroleum-based inks. Check with your letterpress printer to see if low-VOC soy- or vegetable-based inks can be used to print your project.

Letterpress is not the medium of choice for four-color process, but for one- and two-color jobs employing type and graphics, its cost is comparable to or slightly higher

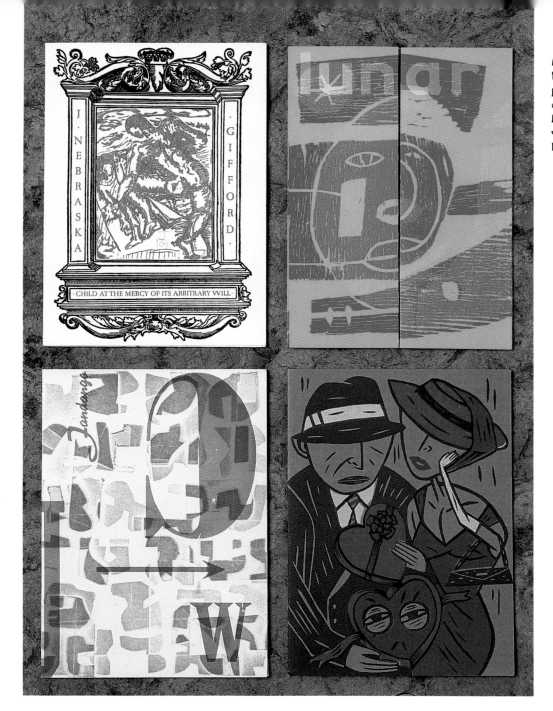

Many letterpress printers issue limited edition runs of art prints in addition to commercial printing. Work pictured here, by a variety of artists, was printed by Purgatory Pie Press.

than offset on small runs. Because fewer copies are generated per minute, letterpress becomes more expensive on longer runs.

Screen Printing

Like letterpress, screen printing offers a way to print on handmade and industrial-grade papers that are not suitable for offset printing. Screen printing is also used for printing on metal and acrylic (most often for signage), T-shirts and other garments, three-dimensional surfaces such as bottles and other containers, and container labels.

The process involves forcing ink through a fabric screen to which a stencil has been applied. The stencil is usually made by a photographic process in which light is exposed through a negative onto a light-sensitive emulsion spread on the screen. Making a photo silk screen requires chemicals that have a negative impact on the environment. The film

Letterpress Printers

CLAUDIA LAUB STUDIO
7404 Beverly Blvd., Los Angeles, CA 90036
(213) 931-1710, Fax: (213) 931-0126

FIREFLY PRESS
23 Village St., Sommerville, MA 02143, (617) 625-7500

INDEPENDENT PROJECT PRESS
40 Finley Dr., P.O. Box 1033, Sedona, AZ 86336
(602) 204-1332, Fax: (602) 204-1332

INNERER KLANG PRESS
7 Sherman St., Charlestown, MA 02129
(617) 242-0689, Fax: (617) 242-0689

JULIE HOLCOMB PRINTERS
665 3rd St., Ste. 425, San Francisco, CA 94107
(415) 243-0530, Fax: (415) 243-3920

MINDANAO PRINTING
1222 Hazel St., N., St. Paul, MN 55119-4500
(612) 774-3768, Fax: (612) 771-9772

NADJA
265½ W. 94th St., New York, NY 10025, (212) 866-5595

PATRICK REAGH PRINTING
1517 Gardena Ave., Glendale, CA 71204
(818) 241-1805, Fax: (818) 548-2473

PURGATORY PIE PRESS
19 Hudson St., No. 403, New York, NY 10013
(212) 274-8228, Fax: (212) 925-3461

QUINTESSENCE WORKING PRESS-ROOM MUSEUM
356 Bunker Hill Mine Rd., Amador City, CA 95601, (209) 267-5470

RED STAR PRINTING
740 N. Franklin, Chicago, IL 60610, (312) 664-3871, Fax: (312) 664-8961

THE SUN HILL PRESS
12 High St., North Brookfield, MA 01535
(508) 867-7274, Fax: (508) 867-7274

W. THOMAS TAYLOR
1906 Miriam St., Austin, TX 78722, (512) 478-7628

WARWICK PRESS
1 Cottage St., Easthampton, MA 01027, (413) 527-5456

that is adhered to the screen is manufactured with silver halides and plastics. The photo emulsion used in the developing process uses toxic substances such as bleach and sodium thiosulfate.

Screen printing generates far fewer impressions per minute than offset, so there is less waste of substrate materials. It works well for printing type and graphics but doesn't allow for the registration and fine-line screens necessary for reproducing fine detail and continuous-tone images in four-color process.

As in offset printing, harmful VOC emissions from inks and alcohol are an environmental hazard. Local ordinances restricting VOC emissions, which are imposed on offset printers, also apply to screen printers. The screen printing industry has responded to the need to limit VOCs by manufacturing water-based inks as an alternative to the solvent-based inks that were widely used a few years ago. However, water-based inks have limited applications. They work well on paper products, but acrylic and glass surfaces require inks formulated with latex, vinyl and similar compounds that are more toxic. The process's degree of environmental friendliness depends to a large extent on the restrictions imposed by the surface being printed.

Industry professionals point out that UV curing (drying inks with ultraviolet lights) and using inks formulated for UV curing eliminate the vaporization that occurs when inks air dry, so toxic compounds in the inks are not a factor as far as VOC emissions are concerned. In fact, water-based inks formulated by UV curing have been approved by the FDA.

The eco-awareness of the shop you are working with will determine whether low-VOC inks are used and other measures are taken to help the environment. To find out if a screen printer uses environmentally responsible practices in its business, ask questions. Find out how toxic substances and inks are disposed of and whether they recycle materials. Find out if they monitor VOC levels in their shop and have taken measures to control them.

Flexography

Flexography (or "flexo" printing) uses rubber or plastic plates on a web press. It is often used for printing on extremely large runs on materials that can't be accommodated on a web offset press, such as plastic and kraft paper. Printed rolls from the flexo press are then trimmed and made into a variety of packaging applications, including labels and bags. Although registration is not quite as accurate as in offset lithography and ink coverage is thinner, the process is extremely fast, printing anywhere from one to four colors in up to one thousand feet per minute.

The process uses water-based inks as opposed to the high-VOC petroleum-based inks most often used for offset and other printing processes. This aspect makes flexography an environmentally friendly process. The only drawback to flexography (and it's a minor one) is that flexo-printed pieces are harder to deink because its water-based inks cause the pigment to seep into paper. Deinked fiber from flexo-printed paper carries so much pigment that a high degree of bleaching is often required to make it useable for fine printing papers. However, flexo-printed paper that contains dyed fiber can be remade into industrial papers without bleaching.

Embossing

Embossing is creating an impression of an image by molding paper around a die. Because the process employs no chemicals or inks, it is one of the most environmentally sound imprinting alternatives. Embossing dies, which are usually made of zinc, brass or copper, can be stored and reused for other applications. As an alternative to offset printing an image, embossing conserves resources such as the film and metal required to create offset negatives and plates. A bonus: Uncoated recycled paper performs beautifully

Flexography is used most often for packaging, labels and shopping bags like these.

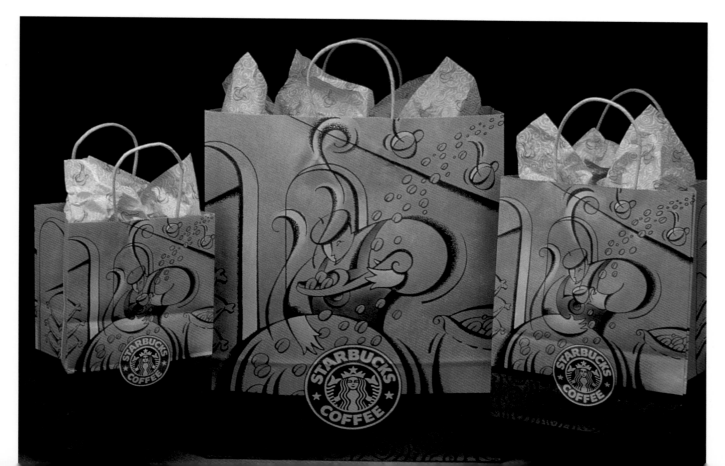

Profile of an Earth-Friendly Print Shop

Some print shops make a conscious effort to reduce their use of toxic inks, alcohol solvents and other substances that are harmful to the environment. They also recycle waste ink as well as all plastic, metal and paper used in the printing process.

If you're wondering if your print shop does its part to preserve our planet, compare its practices with those of Second Nature Graphics, a printer that has made a business of printing in an environmentally responsible manner for environmental action groups such as the Audubon Society and Earth Day 1995. These are some of the shop procedures Second Nature Graphics has instituted:

@ Works exclusively with recycled stocks and vegetable-based inks.

@ Prints with recycled four-color process inks.

@ Uses inks that are free of toxic pigments.

@ Uses a low-VOC, nonalcohol, citric-based, biodegradable press wash made from citrus fruits.

@ Recycles paper and other office refuse.

@ Recycles shop materials such as film negatives and aluminum plates.

@ Recycles inks by separating them into process and match colors. Contracts with a special service that reformulates the ink.

@ Uses shipping cartons made from a minimum of 30% to 50% postconsumer fiber rather than packaging jobs with shrink-wrap or other materials that are less eco-friendly.

@ Will pick up surplus inventory they have printed and take responsibility for recycling it.

@ Has a reforestation project in which trees are planted in ecologically strained areas in the name of clients who specify 100% recycled papers for their print projects.

when embossed. Just remember that the heavier the sheet, the deeper the emboss possible.

Thermography

Thermography uses slow-drying rubber or oil-based inks that are dusted with resinous powder while still wet. After the excess powder has been vacuumed off, the sheet goes into a heat tunnel where the powder melts and fuses with the ink, resulting in a raised dull or glossy finish.

The heat curing in itself wastes resources. Unlike UV finishes that are cured with light, thermography heat tunnels require a large degree of energy to maintain high temperatures. Furthermore, paper printed with thermography is not easily recycled. The heat-set resins fuse with the paper fiber and are not easily extracted in the deinking process. When removed, they contribute more contaminants to the deinking sludge than ordinary petroleum-based inks.

Engraving

This classic technique transfers an image onto a plate by photoetching or hand tooling. After type and graphics have been photomechanically etched into a copper or steel plate, the recessed image is filled with opaque ink. Pressure is applied to the paper as it rolls through the press, so that it is forced into the ink-filled crevices of the plate. Most engraving inks are water-based and/or vegetable-based, meaning they emit fewer VOCs and are less hazardous than petroleum-based inks. However, engraving costs substantially more than offset printing and is used only in special applications requiring large runs. It's used for printing currency, stock certificates, and, in some cases, corporate letterhead when a prestigious look is desired.

Foil Stamping

Foil stamping uses a metal die to imprint paper with a coating of polyester film. The making of the metal die is similar to embossing—it doesn't involve many resources or harmful chemicals, and the die can be stored and reused. However, foil stamping renders paper virtually unrecyclable because the stamping process makes the film almost impossible to remove from the pulp.

Die-Cutting

Cutting an image or graphics into paper involves the manufacture of a reusable zinc, brass or copper die. The die acts like a cookie cutter, cutting away excess paper in a specific design or shape. Aside from the trimmed waste, the process is similar to embossing in its environmental impact. Die-cutting conserves film and metal necessary to offset lithography and eliminates the need for chemicals used to burn offset printing plates and to develop film negatives. There are no printing inks involved and, thus, no contaminants added to the paper fiber, so the paper is easy to recycle.

Varnishes

Varnishes add luster to glossy or dull coated papers, or a matte finish to glossy coated papers. In addition to heightening the visual impact of photos and other images, varnishes are also used to protect printed surfaces against scuffs, scratches and fingerprints. The eco-friendliness of a varnish depends on what type it is. Check the descriptions below to determine which is most appropriate for your project.

Press-Applied Varnish

Applied on press as an ink would be, press varnishes coat the paper with a spot or flood coating in both dull and gloss finishes. They can be applied separately or combined with ink and are available in soy- and vegetable-based formulations.

Aqueous Varnish

This high-gloss coating that you often see on magazines is a mixture of polymers and water that is applied on press with special equipment. In some cases, the varnish is heat set after it is applied. Other aqueous varnishes contain a catalyst that allows the varnish to dry quickly without curing. Although aqueous varnishes are water based, they are harder to remove from paper in the deinking process than press-applied varnishes.

Ultraviolet or UV-Cured Varnish

Applied with roller coaters or by screen printing, ultraviolet coatings produce the glossiest and most durable finish of all varnishes. The process requires curing the varnish in a tunnel, which emanates ultraviolet radiation. UV-cured varnish renders paper virtually undeinkable; in fact, most paper recyclers will not knowingly buy paper that has been UV-coated or laminated.

Binding

The glue used for perfect-bound magazines and brochures is often petroleum-based rubber glue. Generally speaking, avoiding petroleum by-products helps the environment. More important, rubber-based glue is hard to remove in the deinking process. Water-based glue that dissolves during the deinking process has recently become available. Check with your printer or binder to find out if they offer water-based glue on perfect-bound publications.

The Green Studio

The work you have printed with vegetable-based inks on paper with a high recycled content says a lot about your commitment to the environment, but what happens in the course of that project's design? Would your studio practices make an environmentalist wince?

Environmentally responsible designers need to guard against wasting resources in their studio. This chapter focuses on environmentally sound studio practices that will help you conserve energy and recycle resources. As an added incentive, getting into some of these habits will even save you money!

Conserve Electricity

It should go without saying that energy conservation should be your first priority—after all, if you're paying the utility bill, turning the lights and power off when you don't need them saves money as well as electricity. Many designers overlook the chance to conserve in other ways. For instance, you can use daylight to its best advantage by moving your computer workstations into areas with artificial light and reserving areas next to windows for proofing and hand work. Use energy-saving light fixtures such as tensor lamps by your computer. Use energy-saving fluorescent fixtures wherever else you need lighting.

According to the Environmental Protection Agency, personal computers and their peripherals consume as much as 5% of all commercial electricity. By the year 2000, the EPA estimates this figure will be close to 10%. Turning your computer and peripherals off at the end of the day, or whenever they're not being used, also saves electricity.

Beyond turning your computer off, there are a number of power strips on the market available to MS-DOS and Windows users that reduce the amount of electricity flowing into your computer when nobody has been using the keyboard for awhile. Tapping the keyboard restores the power flow to the computer. These power strips are a great option if you have a workstation where a lot of keyboarding is being done, but if you use the mouse a lot, you might find your computer shutting down in the middle of your work.

Green Power Strips

These companies sell MS-DOS- and Windows-compatible power strips that reduce electrical power to your computer when not in use:

B&B ELECTRONICS
4000 Baker Rd., P.O. Box 1040
Ottawa, IL 61350
(815) 434-0846, Fax: (815) 434-7094

CONTEK INTERNATIONAL CORPORATION
303 Strawberry Hill Ave.
Norwalk, CT 06851
(203) 853-4313, Fax: (203) 853-6414

CYPRESS COMPUTER, INC.
Eden Landing Rd., Ste. 6
Hayward, CA 94545
(510) 786-9106, Fax: (510) 786-9553

TRIPP LITE
500 N. Orleans, Chicago, IL 60610-4188
(312) 329-1777, Fax: (312) 644-6505

Conserve Paper

Try to proof and design as much as possible on your computer screen, rather than on printed laser copies. If possible, bring in clients and others involved in the proofing and design process for their input on your design while it appears on-screen. You'll find the creative process may benefit by spontaneously designing as a group, in real time, on the computer screen.

Many environmentally concerned designers have "white boards" (wipeable, smooth-surfaced boards that you can write on with a marker) mounted on their studio and conference room walls for producing sketches. The "white boards" encourage group brainstorming and replace the paper and sketch pads that had formerly been used by

Refurbished & Repaired Computers

These companies refurbish and repair used computers and place them in charitable organizations and other places where they're needed the most:

EAST-WEST EDUCATION DEVELOPMENT FOUNDATION
49 Temple Pl., Boston, MA 02111, (617) 542-1234, Fax: (617) 542-3333

NON-PROFIT COMPUTING, INC.
2124 Wall St., New York, NY 10005-1301, (212) 759-2368

Where to
Recycle
Toner
Cartridges

A dvantage Laser Products will fill your used cartridge with new toner and return it. There are no minimum quantities involved. The company also sells remanufactured cartridges for some printer models. Contact them for more information.

ADVANTAGE LASER PRODUCTS, INC. 2030 Powers Ferry Rd., Ste. 218, Atlanta, GA 30339, (770) 953-2515, Fax: (770) 953-6993

designers for producing roughs and thumbnail sketches.

Make a phone call or e-mail your clients rather than mailing a letter or faxing them. If you need to send a document from your computer, send it by modem. If you have to send a package, padding it with lightweight, biodegradable "eco-foam" peanuts will save paper and make your package lighter (as well as less expensive to ship!).

Recycle Studio Waste

One of the most obvious items to recycle is the paper you use in your laser printer or photocopier. Maintain a bin for printed paper that can be used again for printing on the other side. Used paper can be used for rough drafts and other work that won't be sent or shown to a client.

Toner cartridges can be returned to the manufacturer for recycling. Most manufacturers encourage the recycling of toner cartridges because of the problems discarded cartridges cause in the landfill, and because it is more profitable for them to resell used cartridges to companies that will recycle them. Many sell their toner cartridges with instructions on where to return them for recycling. If your toner cartridge doesn't offer this option, send your cartridges to the recycler listed on this page.

If you've tried to sell used or damaged computer equipment to no avail, don't discard those items. Contact a local charity and donate that equipment—you can take a write-off against your business. Or give your equipment to a company that will refurbish it.

Where to Buy Recycled Diskettes

T hese companies erase used diskettes, relabel them, verify that they are virus free, then sell them back to the general public:

GREENDISK
15530 Woodinville-Redmond Rd., Ste. 400 Woodinville, WA 98072, (206) 489-2550
Wholesaler that sells to retail outlets such as Egghead Software. Minimum quantity is 10. Call them to locate a local retailer.

SOFTDISK PUBLISHING
606 Common St., Freeport, LA 71101 (318) 221-8718, Fax: (318) 221-8870
Mail-order sales of recycled diskettes. Minimum order is 50.

Buy Recycled Products

When it comes to recycled products, an obvious choice is recycled paper for your laser printer and photocopier. Recycled bond usually costs no more than other laser stock. Also look for unbleached paper—it is darker than other bonds, but a high degree of whiteness is usually not important when it comes to generating laser copies.

You can also buy recycled 3½" diskettes. Recycled diskettes often come from out-of-date software packages. Rather than dump these packages in landfills, conscientious software publishers sell them to companies that specialize in recycling the manuals, boxes and floppy disks.

Toner cartridges can also be remanufactured from used cartridges. The manufacturer will simply squirt fresh ink back into an empty cartridge after disassembling, cleaning and inspecting it.

Checklist for a Greener Studio

Having a greener studio just means developing the right habits, most of which fall into one of the three catagories below:

◉ Conserve electricity. Conserve electricity by making use of daylight in your studio and using power-saving electrical fixtures.

◉ Buy recycled. Buy recycled paper, diskettes and other recycled products and equipment for your studio.

◉ Recycle studio waste. Recycle paper from your laser printer as well as printer toner cartridges. Donate damaged or out-of-date computer equipment that can't be sold.

The Client Side of Green Design

Producing eco-sensitive design isn't likely to happen unless you have the support of your client or employer. Although ecologically sound design solutions may not cost more, they can require additional time to source out eco-friendly materials and methods and navigate the learning curve that often results from experimenting with new techniques and materials.

In this chapter you'll gain insight into the kind of clientele that can benefit from and will support an eco-friendly stance. You'll also learn about ways to work around clients who are not likely to respond to the need to conserve and recycle by coming up with environmentally responsible compromises.

Building surgical and medical centers requires attention to detail and careful management. It takes a team who can look at the plans from inside-out. It requires a diagnostic approach to budgeting and estimating. In summary, a company capable of controlling the project from start to finish. Call us at 602-944-5944 to discuss your plans. When it comes to medical construction, we've got the right tools.

Rowland Companies
A Matter of Excellence
Phoenix, Arizona

After researching the market potential, Phoenix-based Richardson or Richardson determined that their client could benefit from a strategic mailing of this promotional piece. The X-ray was sent to a limited number of potential builders of surgical and medical centers in lieu of a conventional direct mail piece sent to thousands on a purchased list.

Cultivating Environmentally Aware Clients

An organization's decision to produce environmentally sound printed materials is usually based on its desire to project an image of social responsibility. Designers wanting to design eco-friendly printed pieces should seek out clients who can benefit from this stance and avoid clients who don't care or don't need to project this image.

Every community has businesses that maintain a high community profile through their support of local causes and events. The difference between a community-spirited organization and one with a less responsible image is often obvious—when it comes down to doing a job for a local night club versus a bank, which business do you think is more likely to be interested in projecting an image that supports social responsibility?

For the most part, community-spirited businesses seeking to project an image of social responsibility and local involvement are already taking measures to support their

stance by sponsoring local events. These businesses are more likely to further their image of social awareness by taking measures that will help the environment.

Designers who are dedicated to incorporating environmentally sound practices into their work need to stress their level of commitment, without ignoring a business's need to get its message across effectively. Very often, clients can be convinced of the benefits in conveying a responsible, environmentally aware image. Business owners who are sensitive to the need to preserve our environment will immediately respond to the idea of an eco-friendly design solution that will also satisfy their business and communication goals. Citing examples and presenting samples of printed materials that bear symbols of environmental worthiness helps to enlighten a client about a practice that is gaining

New York City-based Drentell Doyle Partners decided that folded flyers placed in books would better communicate a political message than wall posters placed in bookstores.

wide acceptance in the corporate community and encourages them to incorporate the same practices and symbol on their printed materials.

It should go without saying that ecologically minded designers should be eco-exemplary in the production of their own identity materials, producing stationery, business papers and self-promotions in an environmentally sensitive manner. Be sure those who receive your self-promotional materials know that you've used eco-

Companies Setting the Trend

The U.S. business community has shown a trend in recent years toward social responsibility, incorporating environmentally responsible practices into management policies, as well as donating products, services and money to social causes. Such posturing would have been construed as radical a few years ago, but today more and more businesses are seeing the wisdom in projecting a dedicated and responsible image to consumers.

A case in point is People magazine, which recently celebrated its twentieth anniversary by donating $3 million in advertising space to social causes. McDonald's has also widely publicized its efforts to develop environmentally friendly packaging in addition to investing millions of dollars in its Ronald McDonald Houses. Ben & Jerry's Homemade, Levi Strauss & Co., Timberland and Reebok International are among other corporations that have incorporated social responsibility into their business policies and produced eco-friendly printed materials that reflect their concern for the environment. These corporations, and others, make a point of letting consumers and shareholders know about their environmental commitment.

friendly production methods by mentioning the high recycled content of the paper and printing with soy- and vegetable-based inks in a brief explanatory paragraph. (Touting your eco-aware methods with too much verbiage wastes paper. Keep it to a minimum.)

Clients Who Don't Care

What if your client is indifferent to environmental causes? Clients who couldn't care less want their own needs to be met before environmental concerns are addressed. If they want the job printed on the cheapest paper possible, they're not likely to pay slightly more for a recycled sheet. If they wanted the job yesterday, they're not likely to wait an extra day for vegetable-based inks to dry.

There's no room for compromise in these situations, but you can still come up with smart design solutions that makes economical use of time and materials. Even though you may not be using paper with a high recycled content or low-VOC inks, strive to produce design solutions that save materials and labor.

Here are some factors to consider:

◉ **Can the job be streamlined?** Ask yourself if your client's budget would be better spent on fewer copies of a piece. Would their promotional needs be better served by a targeted mailing of a high-impact piece to several strategic prospects, or mass-mailing a ho-hum direct mail piece to a list of one thousand?

◉ **Can the size of the piece be reduced?** Sometimes smaller is better. A brochure the size of a paperback book is more likely to be kept and read because it fits neatly into a pocket or handbag. Likewise, a smaller envelope may be opened before a business-sized envelope because the recipient perceives it as a personal invitation.

◉ **Can salvaged materials be used?** Before specing a paper from your swatch books, check with your paper merchant or printer to see if leftover paper purchased for another job would be suitable for your project. Printers and paper merchants often

discount these papers—you'll save money as well as paper that would have otherwise been destined for disposal.

Don't overlook incorporating other materials ordinarily thought of as "trash" into your design concepts. Out-of-date stickers, stamps and other items have been used by designers to add color and character to low-budget jobs printed with minimal color.

Let Them Know How Green You Are

Corporations with a commitment to the environment usually want to publicize this fact on their printed materials with a description of the eco-friendly methods and materials used in their production. They may also seek approval for these materials from groups supporting environmental causes with an "eco-label." Seals for the use of soy-based inks, recycled papers and other eco-friendly methods can be obtained from the following organizations:

1 The National Soy Ink Information Center licenses these trademarks to ink manufacturers and those who use inks with soybean oil content on their printed pieces. No minimum percentages for soybean oil content are required for the symbol, but a user agreement must be signed and filed with the association before camera-ready of the logo is issued.

Contact the National Soy Ink Information Center

1025 Ashworth Rd., #310

West Des Moines, IA 50265-3542

(515) 223-1423, Fax: (515) 223-4331.

2 If you print a job on paper with recycled content, this icon can be obtained from your printer. The American Forest and Paper Association supplies the logo to printers through their trade associations.

For more information contact them at

1111 19th St., NW, Ste. 800

Washington, DC 20036

(202) 463-2700, Fax: (202) 463-2783.

3 Founded in 1990, Scientific Certification Systems exists to recognize eco-friendly materials, products and packaging. SCS issues a cross and globe emblem that appears on products and packaging that meets its requirements.

For more information, contact SCS at

161 Telegraph Ave., Ste. 1111

Oakland, CA 94612-2113

(510) 832-1415.

4 The Canadian government's labeling program for recognizing products that meet its criteria for environmental superiority involves issuance of a license to bear its seal, granted only to products that meet the certification of the Canadian Standards Association. Environment Canada, the issuing agency, can be contacted at

Environment Canada

107 Sparks St., Second Floor

Ottawa, Ontario K1A 0H3 Canada

(613) 247-1900.

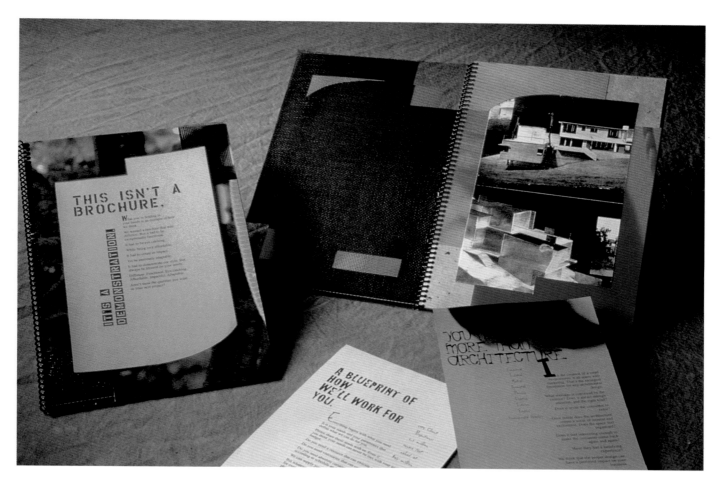

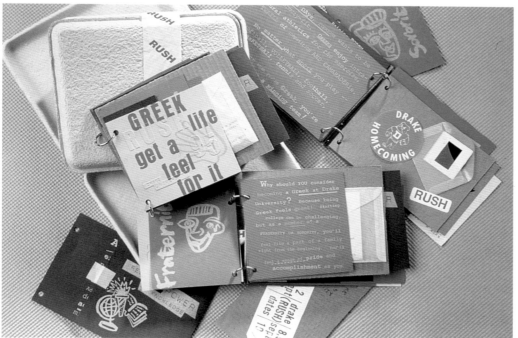

These brochures make creative use of discarded materials to generate visual interest.

Checklist

@ Find socially aware clients who can benefit from projecting an eco-friendly image.

@ Create eco-friendly business and promotional materials.

@ Use symbols of approval from environmental organizations on printed pieces that are prepared in an environmentally kind manner.

Really great, award-winning design is hard to come by. Quality work achieved through environmentally sensitive techniques is even more scarce.

In this section, you'll find a representation of design that has met this two-fold challenge successfully. By learning how these projects were designed and produced, you'll discover how design expertise, combined with a knowledge of eco-friendly materials and techniques, can result in printed pieces that meet a client's objectives in an earth-friendly manner.

When the National Audubon Society issued its 1993 annual report, it wanted a departure from the slick reports of past years that had drawn some criticism from its members. The '93 report had to be a model of environmentally responsible design, from its digital production to its printing on a high recycled content paper.

Designer Steve Jenkins wanted to print the report on a smooth, white stock and showcase full-color reproductions of wildlife photos in crisp detail, but the society balked at the notion of another "slick" report. "Audubon was concerned that people wouldn't perceive the report's paper as recycled," said Jenkins, pointing out that a "granola" look in two colors on brown paper was at one point considered to have a more eco-friendly image. Jenkins noted

that since the report was to serve as a model for other companies, it should achieve what was then perceived as unattainable: a slick, nonrecycled look produced in an environmentally sound manner. Audubon and Jenkins decided to print the report on Mohawk's 50/10, a 50% recycled elemental-chlorine-free sheet. The cover was printed on Neenah Environment, a 100% recycled sheet.

From the onset of the project, all production was done on the computer with the intent of bypassing linotronic output of paper mechanicals and going directly to film. Final proofs were made on recyclable stock.

Jenkins chose Second Nature Graphics, a firm that specializes in environmentally kind printing, to print the report on a waterless press. To minimize

Audubon's 1993 annual report makes the most of outstanding photography with waterless printing.

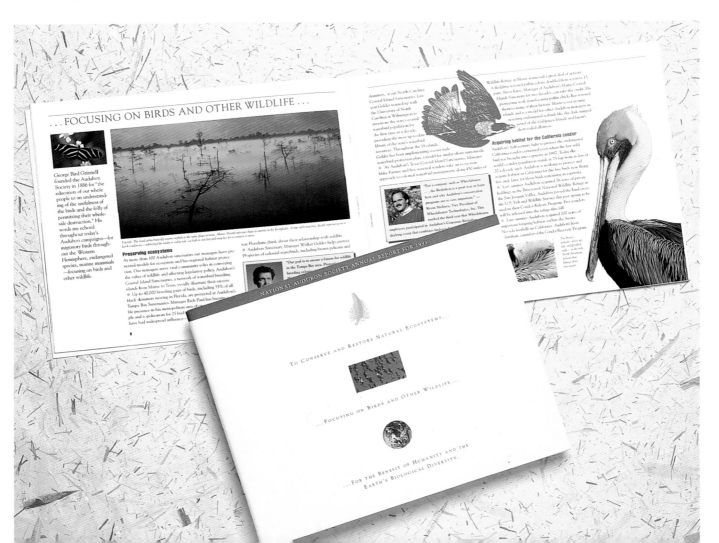

toxic waste and vapors, Second Nature used vegetable-based inks for match colors and recycled four-color process inks as well as a citric press wash. Jenkins says the vegetable-based inks, which usually require additional drying time, didn't make a perceptible difference in the turn-around time for the report.

Jenkins added that the report's eco-friendly production didn't cost much more than conventional methods. "One of Audubon's rules was that it couldn't cost more than 10% over producing it with conventional printing," he stated. The report was done on time and on budget, proving that designers don't need to settle for less aesthetically when producing environmentally kind four-color work. The National Audubon Society was pleased, and asked Jenkins & Page to do their annual report for the following year, too.

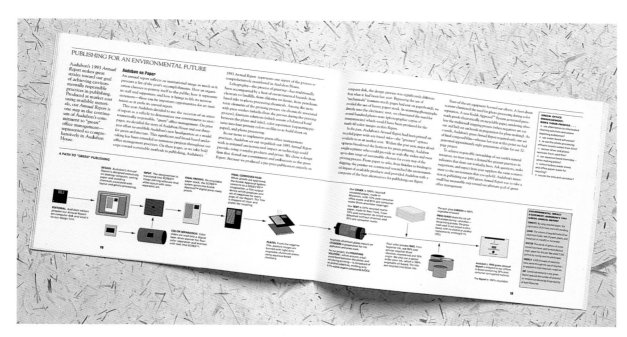

The Audubon Society included a chart in its annual report that describes the report's production so readers can learn from the society's example.

Design Firm: Jenkins & Page Design
Client: National Audubon Society
Design Team: Steve Jenkins
Photography: Various
Printer: Second Nature Graphics

Audubon's 1994 annual report, also designed and produced by Jenkins & Page Design, conveys a different aesthetic but was produced using the same environmentally sound practices as the 1993 report.

One of the tenets of eco-friendly design is to avoid wasting resources. In the case of Bernhardt-Fudyma Design Group, the excess trim on client jobs was put to good use in producing a four-color, self-promotional brochure. In addition to saving paper, Bernhardt-Fudyma produced the brochure for a fraction of the cost of producing it as a separate job.

Firm principal Janice Fudyma had the idea when she and her partner Craig Bernhardt noticed that many of their clients' jobs were printed with a substantial amount of paper trimmed off and discarded. "The extra space was rarely big enough to accommodate an 8½" x 11" page, but since our previous brochure was a 6" x 6" format, and we wanted to maintain that size, we needed very little 'waste' area to fit a page onto the form," explained Bernhardt.

With the approval of its clients, the firm decided to gang one or more photographs or samples of its own work on the discarded trim, and have the photos trimmed into 6-inch squares (or 6" x 12" strips folded to 6" squares) to serve as brochure pages. Bernhardt-Fudyma paid for color separations as well as stripping and trimming the pages but saved substantially on the big ticket items: press time, paper and plates.

Over a period of time, the firm accumulated enough pages (as well as front and back covers) to produce a brochure; however, most of the pages at that point were simply images without identification or description. Bernhardt-Fudyma decided to print vellum interleaf pages to provide the necessary explanation for the image pages, a relatively inexpensive two-color run that produced enough copies of each vellum page for 2,500 brochures.

Bernhardt-Fudyma purchased its own Wire-O binding machine for assembling the brochures. The firm can assemble brochures according to specific types of work or as a general portfolio sampling to send when people call for samples of its work. "It provides us with a very open architecture and enables us to add or substitute new pages as we print them, or break down the contents into a number of sequential mailings," observed Bernhardt. The promotional brochure also works well as a leave-behind after firm principals have made a portfolio presentation.

Design Firm: Bernhardt-Fudyma
 Design Group
Client: Bernhardt-Fudyma Design
 Group
Copywriter: Craig Bernhardt

Bernhardt-Fudyma binds the components of its
self-promotional brochure in its studio.

Alan Lithograph, a Los Angeles-based printer, is doing its part to help the environment. The company was among the first in the industry to incorporate environmentally sensitive procedures into its shop practices, procedures such as using soy-based and recycled inks and instituting in-house recycling.

The printer made a major commitment to the environment in 1994 when it offered to donate $50 to an eco-charity of its clients' choice every time they specified recycled products for their jobs. In support of this commitment, Alan Lithograph produced a brochure describing this offer and the six eco-charities involved and mailed the brochure to its clients.

The firm's brochure focuses on the Yosemite Fund, Nature Conservancy, River Fund, Center for Marine Conservation, National Wildlife Federation and Earth Share California and describes the steps each organization has taken to conserve our natural resources. One of the brochure's most outstanding features is dramatic photography by award-winning photographer Donald Miller. The design team at Los Angeles-based Maddocks and Company focused on these visuals, running them as duotones, to enhance their visual impact.

Making the brochure useful so it wouldn't be quickly discarded was also important. "We wanted the brochure to have keepsake value," said creative director Mary Scott. "By focusing on these charities, we felt the piece would more likely be kept."

To aid in the deinking process, ink coverage was kept to a minimum. Only the pages carrying photos have solid areas of ink. Glued binding was eschewed in favor of a 100% cotton-stitched binding that biodegrades more quickly than plastic or wire mechanical binding.

The brochure was printed on Neenah Environment, a 100% recycled sheet. Soy-based inks were used on a conventional offset press. To keep volatile emissions to a minimum, Alan Litho also used nonalcohol dampening solution on press.

Alan Litho tried to incorporate as many eco-sensitive production methods as possible into the printing of this brochure. To minimize VOCs while the job was on press, soy-based inks were used along with a nonalcohol dampening solution.

Design Firm: Maddocks and
 Company
Client: Alan Lithograph
Creative Director: Mary Scott
Designer: Amy Hershman Rogers
Photographer: Donald Miller
Printer: Alan Lithograph

Although the petroleum industry has taken measures in recent years to incorporate environmentally safe practices into its transporting and manufacturing processes, it still suffers from a negative image. Highly publicized oil spills and past manufacturing processes that have had a negative impact on the environment have all contributed to the public's perception of an industry with little regard for natural resources. British Petroleum wanted to correct this image through its 1994 annual report by stressing the corporation's commitment to the environment.

The report's design team at Cleveland-based Nesnadny + Schwartz realized the importance of producing a report that was as environmentally sound as possible, yet its diverse audience of close to 100,000 recipients required a look with broad appeal. Firm principal Mark Schwartz and the Nesnadny + Schwartz

design team eschewed an obviously recycled look and chose instead to make four-color photographs and duotone portraiture the primary visuals of the annual report cover and opening section. They chose S.D. Warren's Lustro Recycled, with a 50% recycled content for its high gloss, coated surface.

Financial information was printed on French Durotone, an uncoated sheet with 100% recycled content. The report was run on an offset press equipped with a dryer so that the soy-based inks used in its production could be quickly dried. For additional gloss, an aqueous flood varnish was applied to the report's cover.

The glue used to bind the report is recycled and easily removed in the deinking process. Although the glue is easy to purchase now, it was relatively new at the time of the report's printing and was difficult to locate.

Design Firm: Nesnadny + Schwartz
Client: British Petroleum Company
Creative Director: Mark Schwartz
Designers: Mark Schwartz, Tim Lachina
Photographers: Jack Van Antwerp, Panoramic Images
Printer: Custom Graphics

British Petroleum Company needed an annual report that communicated the company's concern for the environment.

The Cleveland Institute of Art's 1995-96 recruitment brochure serves as a good example of how environmentally sensitive materials and processes can be used to produce a dazzling, four-color brochure.

The institute's target audience of art and design students required a brochure with a high level of visual sophistication and upbeat graphics. Critical color reproduction of student art was essential to the success of the brochure. The brochure's designer, Mark Schwartz, of Nesnadny + Schwartz, also wanted the brochure to be eco-friendly. "Everything we do at our firm is as environmentally friendly as we can make it," he explained.

As a result, the brochure was printed on S.D. Warren's Lustro Recycled, a coated paper made up of 10% postconsumer waste that enabled faithful reproduction of the brochure's large, four-color visuals. Soy-based inks were used throughout and a soy-based spot varnish was applied to the photos.

The brochure's large, 9" x 13" format gives additional impact to the artwork. Its attention-getting size also makes economical use of a 40" press as well as the paper's 25" x 38" sheet size. As a result, there was a minimum of discarded waste when the brochures were trimmed.

Design Firm: Nesnadny + Schwartz
Client: Cleveland Institute of Art
Creative Directors: Joyce
 Nesnadny, Mark Schwartz
Designers: Joyce Nesnadny, Brian
 Lavy
Photographers: Mark Schwartz,
 Robert A. Muller
Copywriter: Anne Brooks Ranallo
Printer: Fortran Printing, Inc.

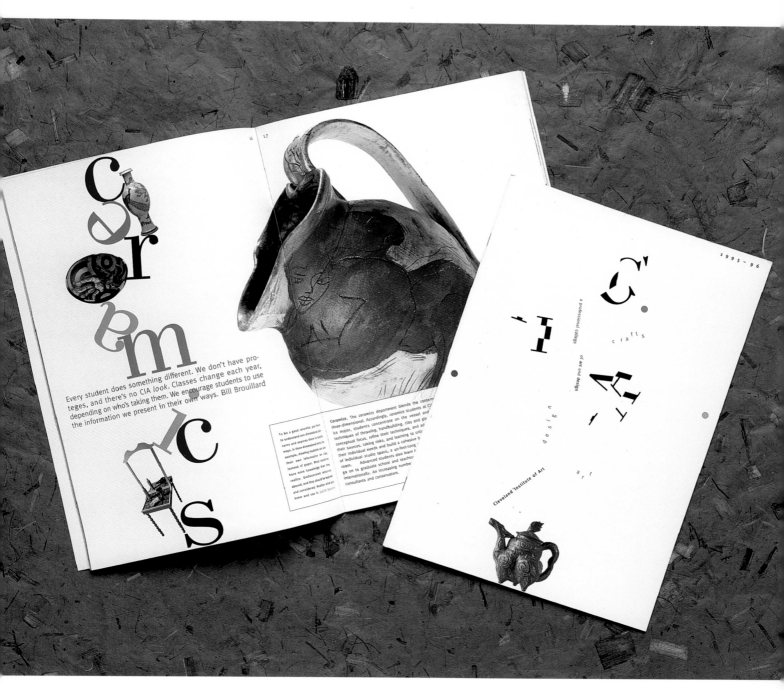

This brochure achieved critical four-color reproduction with soy-based inks and paper with a high recycled content.

Cross Pointe Medallion Sketchbook

This promotional brochure for Cross Pointe's Medallion line is actually a sketchbook. "They're committed to creating pieces that are useable," said the brochure's designer Michael Lizama, in reference to Cross Pointe's desire to produce promotional materials that are more likely to be kept rather than discarded.

Like most paper promotions, *Draw Your Inspiration From Medallion* succeeds in demonstrating the paper line's on-press capabilities on a variety of colors and basis weights. Eight dividers, printed on a cover weight of the stock, showcase a broad cross section of illustration styles. Each of the commissioned illustrators depicts a source of inspiration.

Because Medallion is a 100% recycled paper, it was important to Cross Pointe and the promotional brochure's design team to incorporate as many eco-friendly methods as possible into its production. For instance, printing was done on a waterless press using soy-based inks. Because the paper is acid-free the designers wanted to bring out its archival qualities as well.

The designers were also conscious of how difficult it is to recycle paper printed with heavy ink coverage and elaborate finishing techniques. As a result, they eschewed foil stamping and other techniques often seen in paper promotions and deliberately limited the color in the book to no more than three inks on each of the illustrated dividers. Four-color capability is used only where the most impact is needed: the cover.

Unlike most paper promotions, this one contains many blank pages, but because of the limited color, recipients are more conscious of the even surface and richness of the paper. The net effect is the perception of quality comparable to an art paper.

Design Firm: Little & Co.
Client: Cross Pointe Paper Corporation
Art Director: Paul Wharton
Designer: Michael Lizama
Photographer (cover): Steve Kemmerling
Illustrators: Hungry Dog Studio, John Diebel, Bill Mayer, Henrik Drescher, Ann Field, Dan Craig, Ron Finger, R.M. Kato, Edd Parton, Mike Lizama
Copywriter: Art Novak, Art of Copy
Printer: Litho, Inc.

This paper promotion is a sketchbook. Its functional value and inspirational art by well-known illustrators make it unlikely to be discarded.

Around the turn of the twentieth century, more than 2,500 libraries were built by philanthropist Andrew Carnegie in small towns across the United States. In an effort to preserve the 1,600 Carnegie libraries that remain, architect Lonn Frye, with funding from the Graham Foundation for Advanced Studies in the Fine Arts, commissioned designer DeWitt Kendall to design a brochure that would be sent to urban planners and others in a position to preserve and restore these architectural gems. The brochure romantizes the classic architectural forms of these buildings and highlights architectural aspects that lend themselves to rejuvenation.

Because the brochure concentrates on recycling old buildings, Kendall felt it was important to use recycled materials in the brochure's production. He chose Cross Pointe Genesis, made from 100% recycled fiber, for the brochure's interior pages and Simpson Gainsborough, with a recycled content of 50%.

Because the brochure was sent to each of the Carnegie libraries, Kendall designed title tags as a means of identifying the brochure on the library bookshelves. The silk-screened tags were made from scrapyard copper sheets and tied to the Wire-O binding with leather cord purchased from an army surplus outlet.

More than 3,000 of the brochures were printed on a conventional offset press.

Design Firm: DeWitt Kendall
Client: Frye Gillan Molinaro, Ltd.
Designer: DeWitt Kendall
Copywriter: Lonn Frye
Printers: Omni Printing, Inc.,
 Intermark 7

In addition to its printing on 100% recycled paper, this brochure also includes a title tag made from scrapyard copper.

Cutler Travel Marketing Brochure

Cutler Travel Marketing arranges meetings and conventions at sites around the globe. The company wanted designer John Sayles to help them market its business in a way that could be tailored to customer interest in a specific locale.

Sayles came up with a brochure that alternates text pages carrying the travel company's message with different-colored blank pages that can be customized to fit Cutler's marketing objectives. Cutler employees simply glue in the items that are most appropriate. "They can include handwritten notes, torn sections of outdated maps or trinkets from a country's board of tourism," explained Sheree Clark, director of client services for Sayles Graphic Design.

The items Sayles collected for Cutler to glue into its brochures were not only keepsakes, such as swizzle sticks and swatches of exotic fabric, many of them, such as cancelled stamps and boarding passes, were objects that would otherwise have been destined for the trash heap. The brochure gave new life to these refuse items by transforming them into colorful visuals.

The brochure is wire-bound and encased in an outer wrapper of industrial chipboard. Its interior pages are printed in two colors on Curtis Tuscan Terra, a 60% recycled stock.

Clients are unlikely to quickly discard the brochure that looks more like a scrapbook of exotic mementos than promotional literature. CTM president Bill Cutler said his clients have responded favorably: "They love seeing previews and souvenirs of the destination they're traveling to."

Design Firm: Sayles Graphic Design
Client: Cutler Travel Marketing
Designer: John Sayles
Illustrator: John Sayles
Printer: The Printing Station, Artcraft

Cancelled stamps, fabric remnants and mementos are among the items affixed to the pages of this scrapbook-like brochure.

The Des Moines Metropolitan Solid Waste Agency is responsible for managing and reducing the area's landfill. As such, the agency is also in the business of educating the public on recycling and waste reduction through its annual report.

To get this message across, the Agency's 1991 annual report was printed on a variety of papers with a high recycled content. Its interior pages are printed on grocery sacks and paper made up of 100% postconsumer waste. Its cover, declaring "This annual report is trash," is printed on handmade paper composed entirely of recycled copies of the *Des Moines Register*. The report set a precedent by literally putting trash to work as the primary component of an annual report.

Designers Steve Pattee and Kelly Stiles realized they had a tough act to follow when the Des Moines Metropolitan Solid Waste Agency asked Pattee to design its 1992 annual report. "Because the trash piece was so well accepted and so highly recognized, we were really psychotic about doing this," said Pattee. "We kept trying to redo the trash thing. Then one day we noticed a folder with a bunch of paper samples in it. The papers were sticking out at all kinds of odd angles. We looked at it and said, 'That's it.' "

To get the folder concept across, Pattee used different-colored pages of French Durotone and Fox River Confetti trimmed to odd sizes and shapes to create the look of "found paper." *Closing the Loop*, the subtitle for the report, addresses the need to recycle waste by bringing it back into public use. The theme was reinforced with the report's circular grommet-and-tie file folder closure on its cover. (Even the red circles behind the grommets made economical use of materials—they were cut from scraps of leftover paper used for the report's interior pages.) To recreate the look of a file folder, the cover was made from industrial pressboard, a 75% recycled stock with 50% postconsumer content.

Because the 1991 and 1992 annual reports needed to make economic use of time and materials, inks were limited to two colors. In support of the agency's eco-friendly mission, both reports were printed with soy-based inks.

(Below) "This annual report is trash" is no joke—its cover was printed on paper made entirely from old newspapers. (Right) Industrial pressboard, used for making file folders, was used to recreate the look of a file folder for this annual report.

THIS ANNUAL REPORT IS TRASH

Des Moines-Metropolitan Area
Solid Waste Agency 1991

TRASH CAN BE BEAUTIFUL

It can be recycled into high fashion magazines, low-brow greeting cards, exotic catalogs and corporate brochures. Trash can be profitable. It can be efficiently reused to make new beverage containers, fresh food packaging or fertile garden compost. And we all save in the bargain. We save natural resources, energy and dollars. We save space in the landfill. And we save our environment for future generations. As the new saying goes, "One person's trash is, indeed, everyone's treasure."

Design Firm: Pattee Design
Client: Des Moines Metropolitan
 Area Solid Waste Agency
Design Team: Steve Pattee, Kelly
 Stiles
Copywriter: Mike Condon
Printer: Professional Offset Printing
Papermaker: Jerusalem
 Paperworks

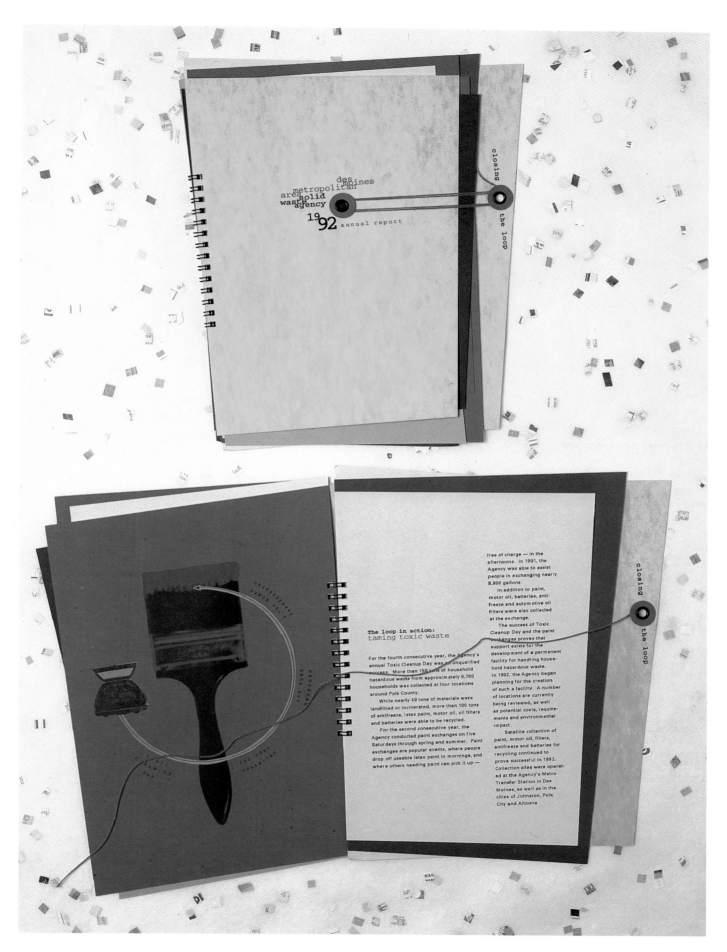

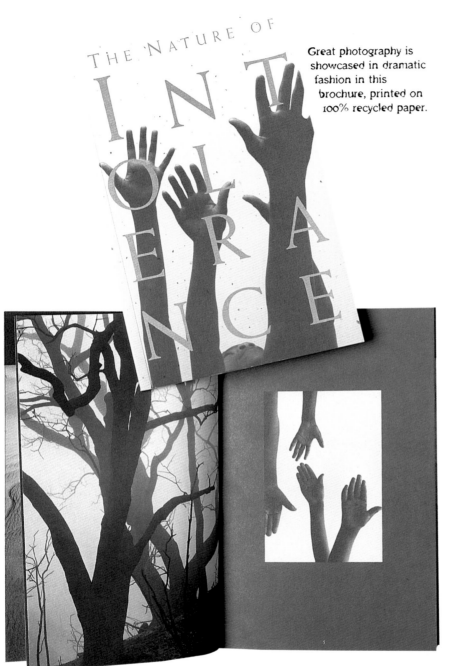

Great photography is showcased in dramatic fashion in this brochure, printed on 100% recycled paper.

Design Firm: Rigsby Design, Inc.
Client: Fox River Paper Company
Design Team: Lana Rigsby,
 Michael Thede, Troy Ford
Photographers: Gary Faye, Bruce
 Barnbaum, Keith Carter
Copywriter: JoAnn Stone

Fox River's Confetti is an uncoated paper noted for its obvious flocking (not unlike a sprinkling of confetti!) and 100% recycled content that includes 50% postconsumer waste. The paper is frequently spec'd when designers want to project an obviously recycled look.

The Nature of Intolerance, a promotional brochure for Fox River's Confetti line, shows that the paper can also be used to showcase dramatic photography in a manner usually reserved for a coated paper or a smooth, uncoated sheet with a lower recycled content.

To achieve these dynamic results, the designers went with a half-size 5½" x 8¾" format—a size that enabled them to compose a brochure of 11" x 8¾" sheets folded in half. Each page of the brochure is actually a folded 80# sheet, printed on one side, with its printed side and folded edge facing outward.

By printing only on one side of the sheet, the designers were able to avoid the problems often attributed to printing solid areas on both sides of an uncoated sheet. By printing on the felt side of the sheet, they achieved smooth, unmottled solid areas without sacrificing fine detail. This yielded maximum impact from the brochure's photographic duotones.

The LTV Corporation's 1994 annual report doesn't boast about its eco-sensitive design and production, yet it was printed on recycled paper with soy-based inks and perfect-bound with recycled glue. The focus of the steel manufacturer's report is the corporation's financial well-being, punctuated with dramatically lit product shots. However, on the last page the following message appears in small print: "Steel is America's most recycled material. In the same spirit of conservation, this report has been printed on 100% recycled paper."

Designer Mark Schwartz, principal of Nesnadny + Schwartz, says that recycled papers and recycled glue cost his client slightly more than conventional materials, but he had no problem convincing the LTV Corporation to go with these eco-friendly materials. "Environmental concerns are a major issue to any manufacturer," he explained.

Nesnadny + Schwartz has been working with recycled papers, soy-based inks, and other eco-friendly production materials for many years, tracking down hard-to-find products and tackling on-press problems that environmentally concerned pioneers encountered long before eco-awareness went mainstream. Schwartz notes that products that are relatively commonplace today, such as the recycled glue that was used to bind this annual report, were hard to find three years ago. Schwartz, like most designers and printers, has also noticed that the quality of recycled papers is vastly improved over what it was several years ago when many lines were first introduced.

Schwartz says his firm now uses recycled papers on 90% of its jobs. He chose S.D. Warren's Lustro Dull Recycled, a coated stock, to best represent the duotone reproductions of the dramatic photography in the front portion of the LTV report. The financial section in the back of the report was printed on French Dur-O-Tone, an uncoated paper with 100% recycled content.

Design Firm: Nesnadny + Schwartz
Client: The LTV Corporation
Design Team: Mark Schwartz, Tim Lachina
Photographer: Design Photography, Inc.
Printer: Custom Graphics, Perlmuter Printing

The LTV Corporation's annual report is made from all recycled materials. In addition to using recycled paper, the report is perfect-bound with recycled glue.

Businesses in the Des Moines area wanting to help in the effort to reduce waste and recycle have measures easily spelled out for them with this brochure. Distributed by the Des Moines Metropolitan Area Solid Waste Agency, the brochure's economical design makes maximum use of a minimal amount of paper and materials.

The brochure's designers, Steve Pattee and Kelly Stiles, took a modular approach when designing the brochure's interior. The brochure actually is composed of six "minibrochures" that are bound together to make a custom brochure appropriate to each business's special needs.

Regardless of how they are organized, the brochure's components are easily integrated into a cohesive whole, because consistent design elements help the individual brochures work together visually. Agency staffers enclose the selected minibrochures in a cover wrapper secured by a large metal clasp normally used for securing reports and legal briefs. A paper flap, printed on the agency's laser printer, customizes each cover for its intended recipient.

Printed on various weights and with coordinating colors of French Dur-O-Tone, the cumulative effect is one of a well-coordinated brochure with enough color and textural variety to provide visual interest.

To keep ink and prepress production to a minimum, the designers chose a bold typographical treatment, rather than halftones, for visual excitement. To reinforce the brochure's ecological theme, all pages of the brochure were printed with soy-based inks.

Design Firm: Pattee Design
Client: Des Moines Metropolitan Area Solid Waste Agency
Design Team: Steve Pattee, Kelly Stiles
Copywriter: Mike Condon
Printer: Seward Graphics

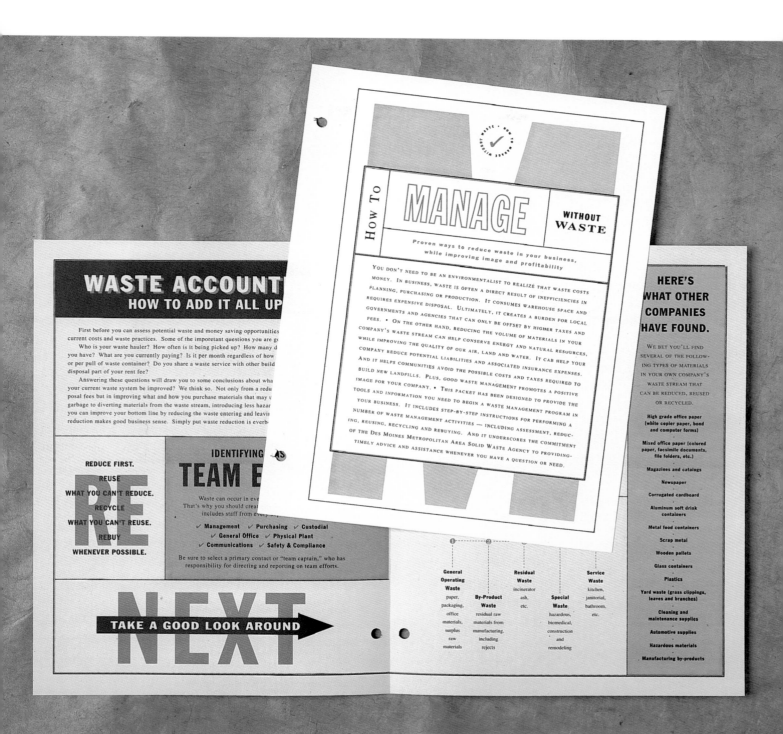

WASTE ACCOUNTI[NG]
HOW TO ADD IT ALL UP[?]

First before you can assess potential waste and money saving opportunities [...] current costs and waste practices. Some of the imporetant questions you are go[...]

Who is your waste hauler? How often is it being picked up? How many d[...] you have? What are you currently paying? Is it per month regardless of how [...] or per pull of waste container? Do you share a waste service with other build[...] disposal part of your rent fee?

Answering these questions will draw you to some conclusions about wha[...] your current waste system be improved? We think so. Not only from a redu[...] posal fees but in improving what and how you purchase materials that may [...] garbage to diverting materials from the waste stream, introducing less hazar[...] you can improve your bottom line by reducing the waste entering and leavi[...] reduction makes good business sense. Simply put waste reduction is everb[...]

REDUCE FIRST.
REUSE
WHAT YOU CAN'T REDUCE.
RECYCLE
WHAT YOU CAN'T REUSE.
REBUY
WHENEVER POSSIBLE.

RE

IDENTIFYING [...]
TEAM E[...]

Waste can occur in eve[...]
That's why you should crea[...]
includes staff from ever[...]

✓ Management ✓ Purchasing ✓ Custodial
✓ General Office ✓ Physical Plant
✓ Communications ✓ Safety & Compliance

Be sure to select a primary contact or "team captain," who has
responsibility for directing and reporting on team efforts.

NEXT
TAKE A GOOD LOOK AROUND ➤

How To MANAGE WITHOUT WASTE

Proven ways to reduce waste in your business,
while improving image and profitability

You don't need to be an environmentalist to realize that waste costs money. In business, waste is often a direct result of inefficiencies in planning, purchasing or production. It consumes warehouse space and requires expensive disposal. Ultimately, it creates a burden for local governments and agencies that can only be offset by higher taxes and fees. • On the other hand, reducing the volume of materials in your company's waste stream can help conserve energy and natural resources, while improving the quality of our air, land and water. It cab help your company reduce potential liabilities and associated insurance expenses. And it helps communities avoid the possible costs and taxes required to build new landfills. Plus, good waste management promotes a positive image for your company. • This packet has been designed to provide the tools and information you need to begin a waste management program in your business. It includes step-by-step instructions for performing a number of waste management activities — including assessment, reducing, reusing, recycling and rebuying. And it underscores the commitment of the Des Moines Metropolitan Area Solid Waste Agency to providing timely advice and assistance whenever you have a question or need.

**General
Operating
Waste**

paper,
packaging,
office
materials,
surplus
raw
materials

**By-Product
Waste**

residual raw
materials from
manufacturing,
including
rejects

**Residual
Waste**

incinerator
ash,
etc.

**Special
Waste**

hazardous,
biomedical,
construction
and
remodeling

**Service
Waste**

kitchen,
janitorial,
bathroom,
etc.

HERE'S WHAT OTHER COMPANIES HAVE FOUND.

We bet you'll find several of the following types of materials in your own company's waste stream that can be reduced, reused or recycled.

High grade office paper
(white copier paper, bond
and computer forms)

Mixed office paper (colored
paper, facsimile documents,
file folders, etc.)

Magazines and catalogs

Newspaper

Corrugated cardboard

**Aluminum soft drink
containers**

Metal food containers

Scrap metal

Wooden pallets

Glass containers

Plastics

**Yard waste (grass clippings,
leaves and branches)**

**Cleaning and
maintenance supplies**

Automotive supplies

Hazardous materials

Manufacturing by-products

This brochure is actually composed of several "minibrochures"
that can be combined as necessary to produce a custom
brochure for each recipient.

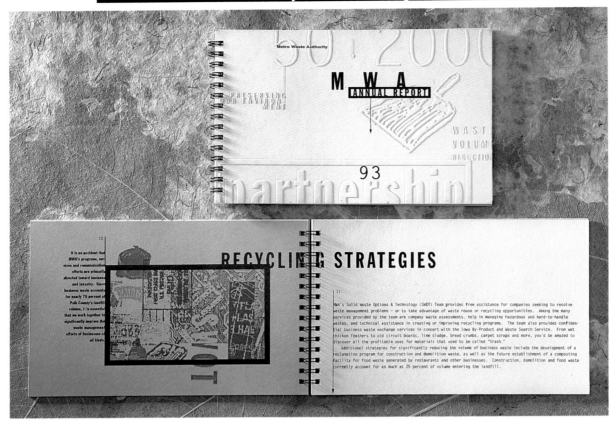

Des Moines' Metro Waste Authority's 1993 annual report embodies the city's goal of reducing waste volume by half. The report itself is half-size.

Design Firm: Pattee Design
Client: Metro Waste Authority
Design Team: Steve Pattee, Kelly
 Stiles, Michael Braley
Copywriter: Mike Condon
Printer: Professional Offset

Des Moines' Metro Waste Authority, like other agencies responsible for waste management, has made reducing the region's landfill one of its primary missions. In its 1993 annual report, the authority targeted the year 2000 as its goal for reducing the Des Moines area's waste volume by 50%.

"We decided to reduce the paper in the annual report by 50%," said designer Steve Pattee when explaining the report's 8½" x 5½" size. The report's half-size format not only reinforces the annual report's message, it also saves paper. The paper used in the report, Champion Benefit, has a recycled content of 100%.

Pattee Design took additional measures to ensure the annual report would be as eco-friendly as possible. Printed in two colors with soy-based inks, the report used a minimum of ink—its cover graphics consist primarily of blind-embossed type and imagery. Interior color was provided by the colored stock rather than additional ink.

The report's production also minimized prepress materials. The design team eschewed image reproduction that would have required film negatives and plates for a more graphic approach. Because the report's run was limited to 2,500, the printer was able to print from paper rather than metal plates. The report's abstracted images and unusual typographic treatment provided so much visual interest, they more than made up for the report's absence of photos.

Because most of the report's readers weren't interested in the authority's financial information, the designers chose to print 1,000 copies of this information on a separate sheet that was inserted into die-cut slots on the interior back cover. Treating this section as a separate item saved money as well as paper because printing the financial insert was easily handled by a duplicator.

Educating the public on how to conserve and recycle is one of Des Moines-based Metro Waste Authority's primary objectives. When the agency commissioned Pattee Design to design its 1994 annual report, the Pattee design team immediately hit upon the idea of reinforcing the agency's educational mission with a flash card format. Printed on industrial chipboard with soy-based inks, each card addresses a measure businesses and consumers can take to help reduce the area's landfill.

Since only about half of the report's recipients were interested in the agency's financial information, printing this information separately and including it with 50% of the reports saved paper. The financial booklet is printed in black ink on French Dur-O-Tone, a recycled paper made of 100% recycled fiber. Its spare look echoes the simple iconography of the flash cards, which were purposely printed with a minimal amount of ink to conserve materials and aid the deinking process.

The cards were secured with, as Pattee put it, "an obviously used rubber band" and sent with a preaddressed label and a letter asking the recipient to recycle the flash cards by forwarding them to a local school. The agency was pleased with the 70% response their request generated.

Design Firm: Pattee Design
Client: Metro Waste Authority
Design Team: Steve Pattee, Kelly Stiles
Copywriter: Mike Condon
Printer: Holm Graphic

Printed with soy-based inks, these flash cards are actually an annual report.

This unusual brochure uses old shipping tags, stickers and other items as its visuals. It was shipped in a molded fiberboard container made from 100% recycled fiber.

"Greek Life: Get a Feel for It" supports its contention by incorporating unusual textures and nontraditional materials.

Sent to recruit students for the sorority/fraternity Greek rush at Drake University, the brochure's intriguing mailer must have found recipients "rushing" to open it. Designer John Sayles chose to enclose the brochure in a molded fiberboard container ordinarily used for meat and other food items. The containers, molded from 100% recycled fiber, were purchased through a local paper merchant that deals in industrial papers and paper products.

Some brochure pages were offset printed in two colors on Curtis Tuscan Terra and Curtis Tuscan Antique, papers with a total recycled content of 60%. The pages were trimmed in a variety of sizes to give the brochure the look of a haphazard collection of items.

Other brochure pages were cut from chipboard and corrugated cardboard. These pages have momentos attached, such as a scenic slide of the school enclosed in a glassine envelope. Hand-stamped slogans and images, as well as dated stickers and shipping tags, items that would have otherwise been discarded, were added to these pages for their color and visual interest.

The brochure's unusual cover is actually an aluminum printing plate, burned with the cover image but never actually used to transfer ink to paper. Sayles was able to use manufacturer rejects for the covers by purchasing imperfect plates from a local printer.

The brochure's pages are bound with wire rings that, like many of the items within the brochure, can be reused. Drake University students did all of the hand-assembly work (including the hand stamping and tipping of inserts) for a total of 1,000 brochures.

Design Firm: Sayles Graphic
 Design
Client: Drake University
Designer: John Sayles
Illustrator: John Sayles
Printer: Action Print

AIGA/Seattle Sound Design Materials

In 1992 Partners in Design, a young design firm based in Seattle, applied for a grant from the Puget Sound Water Quality Authority. The Pacific Northwest has long had a national reputation for environmental awareness, but Partners in Design saw the need to communicate complex and constantly changing environmental information in an effective way to the graphic design community. Principals Sharon Mentyka and Stephen Schlott, in collaboration with local designer Cindy Bell, proposed funding for a peer education project to help graphic designers and print buyers understand and use more environmentally sensitive practices in their work.

Partners in Design got their grant and, with the Seattle AIGA, produced a series of posters (featured on page 136), a two-night workshop, and a comprehensive sixteen-page brochure that covers many aspects of eco-friendly design. The brochures and posters were distributed at the workshop and made available to designers through publicity received from the AIGA's national office, as well as from magazines such as *Communication Arts*, *Print* and *Sierra Magazine*.

The brochure, *Sound Design*, addresses environmental issues designers should know about: toxic inks, recycled and non-chlorine-bleached papers, and more. Because of its serious subject matter, the brochure needed to be designed and produced in an eco-sensitive manner, yet its audience demanded a sophisticated visual approach.

Partners in Design avoided an obvious "green" look for the brochure and posters. "We knew we weren't going to win anyone over if we designed in an earth-friendly vacuum. We wanted to use our creativity to demonstrate that designing with the environment in mind is extremely adaptable and not limited to any single 'look,' " said Mentyka when explaining how the project's design objectives evolved.

Printed on Cross Pointe Genesis, a 100% recycled paper, the brochure was printed in two colors with donated inks from Bio-Tech, a Canadian-based ink manufacturer that uses canola oil in its ink formulation. Mentyka says the brochure's printer was a bit apprehensive about using the unfamiliar inks but was immediately won over by their on-press performance. The printer has since made a vegetable-based ink its house ink.

Design Firm: Partners in Design
Client: AIGA/Seattle
Designer: Sharon Mentyka
Printer: K&H Printers

The Sound Design brochure (left) echoes the visual treatment used for the invitation to the Sound Design workshop (right).

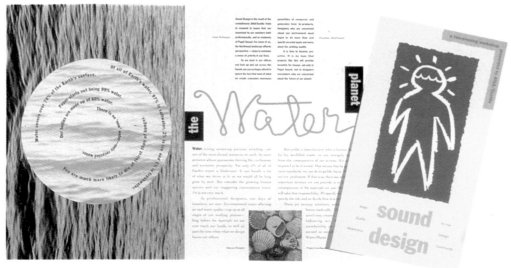

VH-1 "Honors" Event Program

This "book" is actually a program for VH-1 Honors, an annual event that honors musicians who have contributed greatly to a charity or organization that works to improve our quality of life.

The front of the book includes program acknowledgements as well as biographies and photos of the nine artists who were honored. These two signatures were printed on Potlatch Decade 10 and Mohawk Vellum Recycled and were bound along with re-covered, out-of-date library books into new, hardcover books bearing the VH-1 Honors title on the cover.

The re-covered library books were out-of-date textbooks, almanacs, and books with badly destroyed covers that were considered unsalvageable. In addition to giving the books new life, VH-1 made donations to the Friends of the Minneapolis Library for new books and to the Literacy Volunteers of America. About 4,000 of the out-of-date library books were used to make 10,000 new books.

A surprise is revealed in the middle of each program. The pages of the out-of-date portion had been die-cut to form a window that frames a coppery, three-dimensional image of the earth within. The impression is much like finding a valuable item that was hidden between the pages of a book for safekeeping. Designer Sharon Werner and her client searched extensively for globes that would be suitable for the books. Her client finally spotted the miniglobes on earrings and contracted with the jewelry designer to use the same mold to produce 10,000 globes. The copper globes were then glued to the inside back cover of each book.

In addition to functioning as event programs, the books were designed to be kept as a commemorative piece. Given their substantial size, recipients would have been hard-pressed to discard them.

Unsalvageable library books were given new life as the basis for these case-bound programs for VH-1 Honors, an annual event that honors musicians.

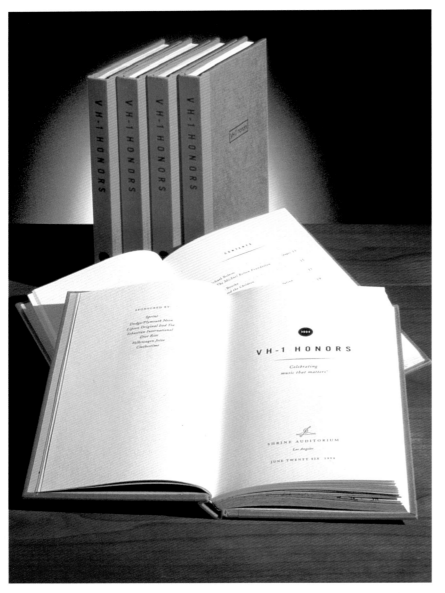

Design Firm: Werner Design Werks
Client: VH-1 Network
Creative Directors: Cheri Dorr,
 Sharon Werner
Designer: Sharon Werner
Copywriter: Dan Hedges
Printer: Diversified Graphics
Bindery: Midwest Additions

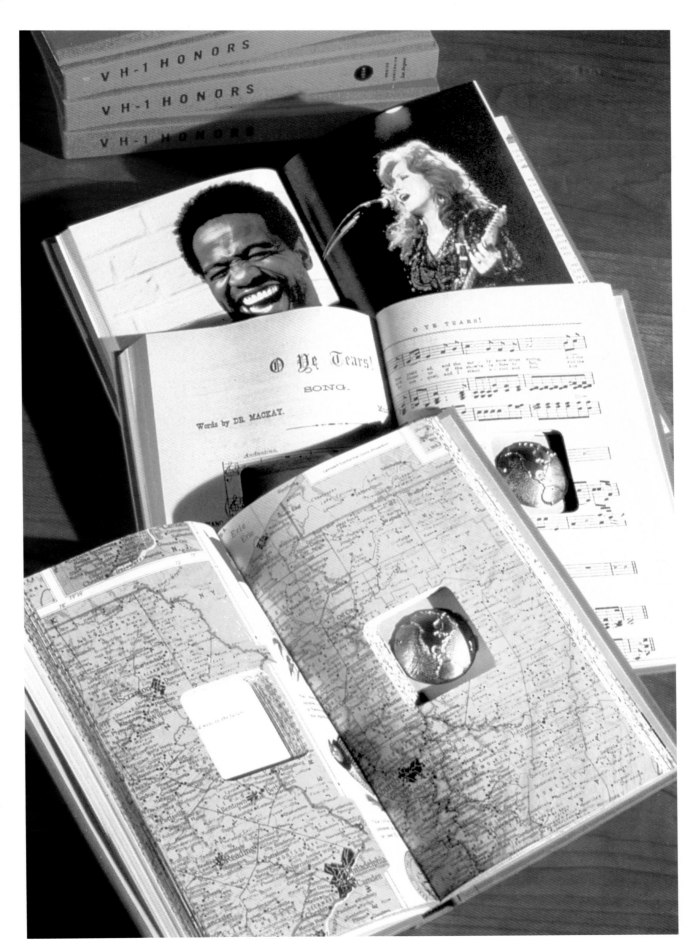

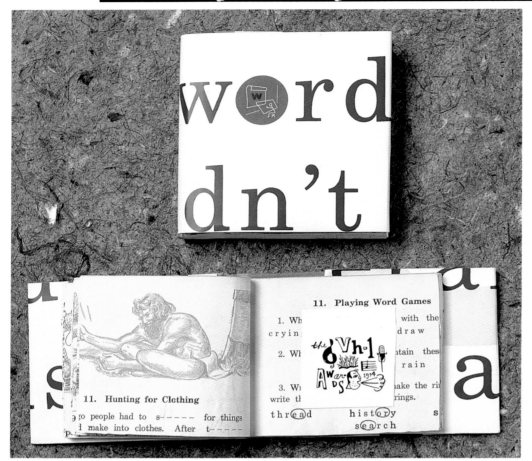

Werner Design Werks rejuvenates out-of-date books by cutting them down to a small scale and using them as "scrapbooks" for its logo designs. The dimensions of this book are 3½" x 4½", but dimensions for other books have varied, depending on the size of the original book.

Werner Design Werks makes an immediate impression with this self-promotional book of logos. The brochure appears to be a substantial hardcover volume of work when, in fact, it's actually an out-of-date book that had been cut down to a size appropriate for its subject matter. The book's pages include glued-in copies of Werner Design Werk's logos.

Designer Sharon Werner hit upon the idea of using old books when sourcing out-of-date books for another job. The books used for the logo promotion are children's word books accumulated from yard sales and from the local library, which donated its out-of-date books. Werner used a hacksaw and utility knife to cut the books down to their minidimensions.

The logo samples were ganged onto a single 8½" x 11" sheet and printed on an offset press. The logos were then trimmed into individual squares and glued onto the pages of the existing book. The vintage look and yellowed paper of the original books provide a charming backdrop to the crisp, black-and-white logos.

Werner devised a custom cover bearing her logo by cutting strips off a dated self-promotional poster and wrapping them around the covers of the out-of-date books.

The logo book has been well received, prompting Werner to produce forty-two of them to date. "People are immediately drawn to its tactile qualities," said Werner.

Design Firm: Werner Design Werks
Client: Werner Design Werks
Designer: Sharon Werner
Illustration: Sharon Werner
Printer: Custom Color

The Starbucks Corporation is well known for serving and selling premium coffees in nearly three hundred stores nationwide. What's not widely known about the company is its commitment to the environment. Starbucks markets an organic product, grown without harmful chemicals or fertilizers and takes measures to conserve and recycle in many areas of its operation. When Starbucks asked Hornall Anderson Design Works to design its annual report, the company wanted a look that reflected its environmental commitment.

Designers Jack Anderson and Julie Lock conceived a report, based on their previous work in developing product packaging, with an interior printed entirely on industrial kraft paper. Its pages feature colorful illustrations in a warm palette of celadon green, terra-cotta and ochre. In addition to its environmental sensitivity, the combination of the brown kraft and earthy colors projects the warm, rich image the coffee retailer conveys with its product packaging (which Hornall Anderson also designed) and in-store fixturing.

The report was printed with soy-based inks on a conventional offset press. To aid in the deinking process, it was printed with a minimal amount of ink; in fact, the cover carries a Starbucks logo blind-embossed in strong relief. French Speckletone, with a high recycled content of 80%, was chosen for the cover for its industrial look and high recycled content.

To save envelopes, the report was sent to shareholders as a self-mailer. Each report was sealed with one of the gummed stickers that are used on Starbucks' packaging.

Design Firm: Hornall Anderson Design Works
Client: Starbucks Corporation
Design Team: Jack Anderson, Julie Lock, John Anicker, Lian Ng
Illustrator: Julia LaPine
Copywriter: Sam Angeloff
Printer: Graphic Arts Center

The Starbucks Corporation's annual report reflects the company's environmental awareness in its use of soy-based inks and industrial kraft paper.

This series of brochures relies on the texture of a heavily flocked recycled sheet for visual interest.

The Hackett Group is a rapidly growing management consultancy with a need to develop literature that appeals to a sophisticated business audience. "They wanted to present visually dry information in a compelling way," explained Mark Schwartz, principal of Nesnadny + Schwartz, explaining Hackett's marketing objectives.

The Nesnadny + Schwartz design team came up with a series of three brochures that projects the approachable image Hackett was seeking to achieve. The literature just happens to be environmentally friendly, as well. "It's pretty much our policy to use environmentally sensitive methods and materials," said Schwartz, referring to the firm's decision to print the brochures with soy-based inks on Neenah Classic Crest, a paper with a high recycled content of 60%.

Schwartz said the flocked-texture paper choice was also an aesthetic one:

"The tactile quality of the paper was important because there aren't a lot of visuals in these pieces." An 80# cover weight was used for a trifold brochure, while the 65# text weight was chosen for two saddle-stitched brochures. The bulk of the uncoated text added substance to the brochures (one totals eight pages, the other sixteen). Schwartz admitted that the cost of the recycled paper was slightly more than a virgin paper or one with a lower recycled content. However, he said that the decision was not a significant factor with the job's relatively small run of 5,000 for each brochure. He points out that the more expensive paper would have had a greater impact on the overall cost had the quantity been much larger.

All three brochures were printed in several match colors with soy-based inks on a standard offset press equipped with special dryer for the inks.

Design Firm: Nesnadny + Schwartz
Client: The Hackett Group
Creative Director: Mark Schwartz
Designers: Mark Schwartz, Tim Lachina
Printers: Great Lakes Litho, Master Printing

Designer DeWitt Kendall's stationery system is based on a contrasting, yet compatible, combination of materials. The letterhead is printed on an expensive paper imported from India, handmade from recycled cotton rags and rice husks. Its rich texture contrasts markedly with the simplicity of a grommet-tied kraft envelope that is typically used for coins and currency. Kendall's business card is printed on industrial chipboard. Although these materials are commonly linked in that they are all composed of 100% recycled materials, their consistent graphic treatment in copper and black gives them visual unity.

"I really like to combine expensive materials with those which are inexpensive," said Kendall, explaining his rationale behind creating design harmony with such disparate stock. "It proves the perceived value of an item is dependent on its context." His choice of eco-friendly yet unusual materials meant the job could not be printed on an offset press. All items were printed on a letterpress.

Kendall said the only problem encountered in production was finding a shade of chipboard that coordinated with the brown of the kraft envelope. He pointed out that chipboard comes in grey and varying shades of brown—finding the right shade proved more difficult than he expected.

Although Kendall's letterhead has a high degree of texture, it can be run through an inkjet printer as well as hand-fed through a laser printer.

Design Firm: DeWitt Kendall
Client: DeWitt Kendall
Designer: DeWitt Kendall
Printer: Amos Kennedy & Sons

This stationery system's richly textured letterhead is in marked contrast with its grommet-tied kraft envelope. The stationery and business card are all made from 100% recycled materials.

Businesses wanting to make an impression often rely on a splashy, colorful letterhead to catch their clients' attention. However, Acme Rubber Stamp's letterhead and business cards make an impact with a conceptual approach that is both clever and conservation-minded in its simplicity.

According to designer Dave Eliason, the company wanted to create a memorable impression on a limited budget. The idea of stamping Acme's name in red on the company's business materials allowed the stamp manufacturer to have a three-color letterhead and business cards for the cost of a two-color run. All of Acme's business materials were printed on a standard offset press on an eco-friendly paper, French Dur-O-Tone with 100% recycled content.

"They were pleased to save money," said Eliason, who adds that Acme employees stamp the company name on 2,000 sheets of letterhead and business cards when they have a free moment or as they need them. Limiting the press run to a two-color run with no bleeds saved ink and paper and gave Acme an opportunity to show off its product.

Design Firm: Peterson & Company
Client: Acme Rubber Stamp
Design Team: Bryan L. Peterson,
 Dave Eliason
Printer: Monarch Press

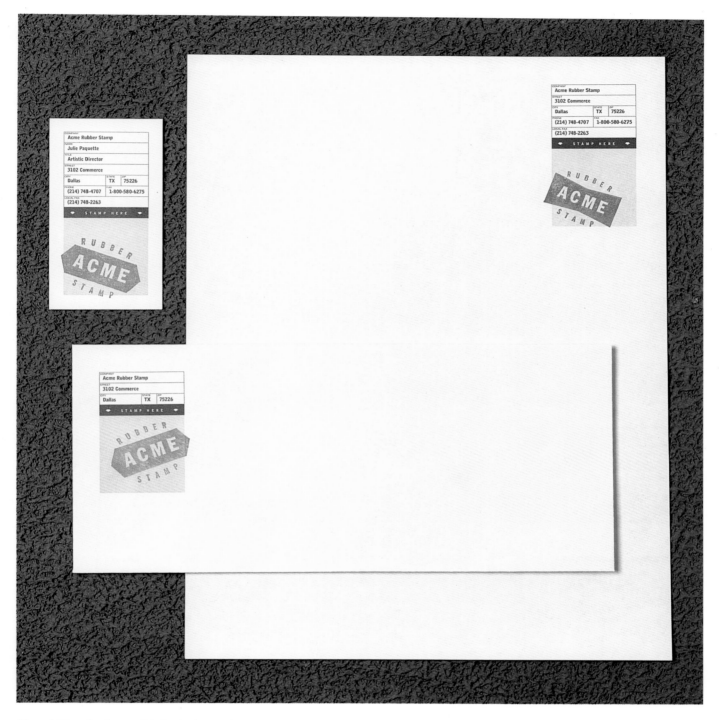

The additional color on this budget-conscious
stationery system is supplied with rubber
stamps.

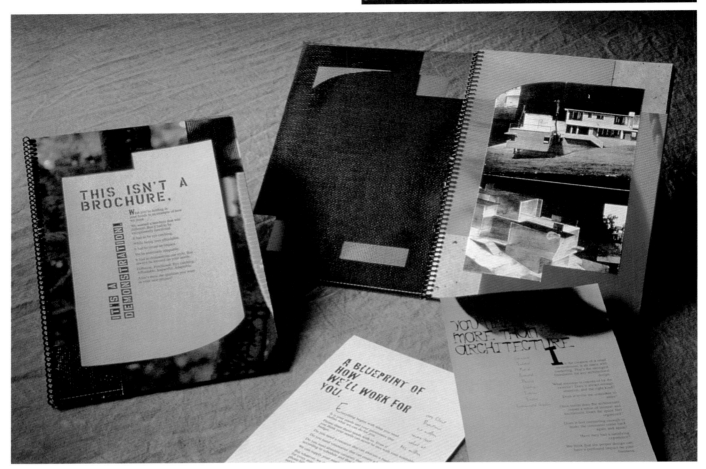

Trashed materials serve as the primary component of this architect's capability brochure.

Design Firm: Studio MD
Client: Bruce Rudman, AIA
Design Team: Jesse Doquilo, Randy Lim

Recycled trash is a primary component of this unusual business card and capabilities brochure for Los Angeles architect Bruce Rudman. Designer Jesse Doquilo, of Seattle-based Studio MD, said he and Randy Lim came up with the idea in response to Rudman's request for a low-budget brochure that he could customize himself.

The brochure made use of old blueprints, chipboard, segments of posters, calendar pages and other discarded items by using them as slotted pages that can accommodate a variety of inserts. The die-cut pages were all cut to the same shape and with the same slot—a rectangular notch at one end, and curved notch at the other—to give the brochure consistency.

Rice papers, screen mesh and other purchased materials were placed between the die-cut pages to contrast in shape and texture with the slotted paper. All pages were wire-bound for the final brochure. Rudman inserts photos of his work and generates inserts on his own laser printer as needed. "That way he can customize it for his prospective audience," explained Doquilo.

The brochure has the textural interest and color of a four-color brochure printed on a variety of papers but cost a pittance—production expenses were limited to the cost of the binding and the trimming and die-cutting of the pages.

The brochure is not only unique and visually exciting, its recycling of discarded waste makes a statement about Rudman's inventive use of resources.

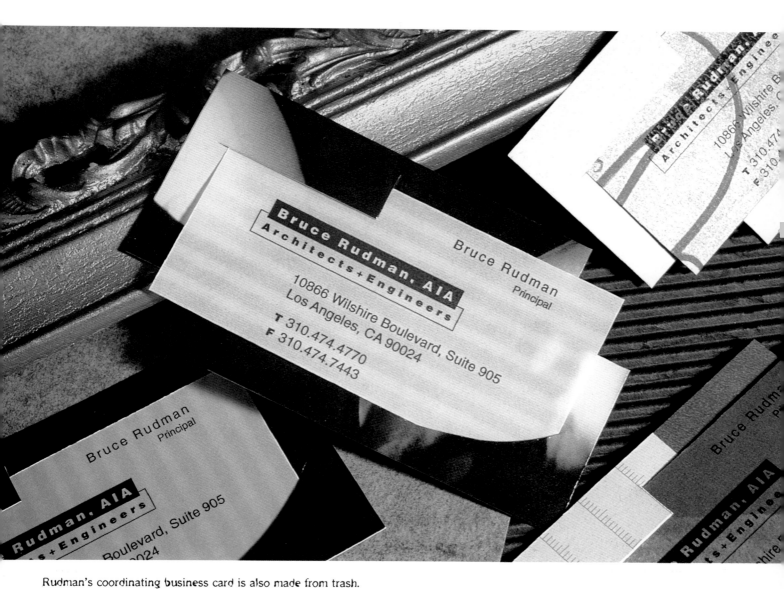

Rudman's coordinating business card is also made from trash.
Die-cut slots accommodate an insert with his name, address and
phone number.

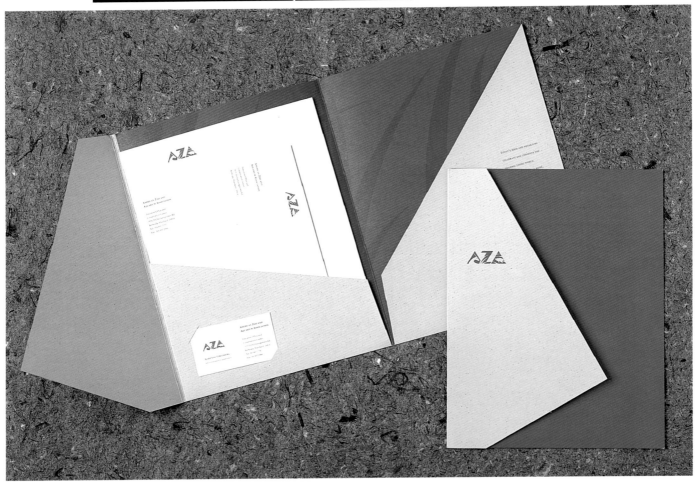

Business materials for the American Zoo and Aquarium Association successfully marry an earth-friendly look with a businesslike image.

The American Zoo and Aquarium Association's mission is to conserve and protect natural habitats and endangered species. As such, the group needed to project this image with printed materials that were preservation-minded and clearly made economical use of resources.

Grafik Communications first came up with a logo for the association that conveys animals in their habitat, as opposed to in cages. From there, the firm developed identity materials for the group that successfully combine an earthy look with a conservative, businesslike image.

The association's business materials include stationery and a folder used for public relations materials, media presentations, and endangered species advocacy literature. Printed on James River Grafika 80# cover, with a recycled content of 50%, the folder forgoes environmentally harmful finishing techniques such as laminating or foil stamping and makes use of a clever die-cut to project an eye-catching image.

In keeping with the association's image of conservation, its stationery is printed with minimal ink coverage on Neenah Environment, a 100% recycled sheet with 25% cotton content. Soy-based inks were used on all of the association's business materials.

Design Firm: Grafik
 Communications Ltd.
Client: American Zoo and
 Aquarium Association
Design Team: David Collins,
 Gretchen East, Susan English,
 Judy Kirpich
Printer: S&S Graphics

The League of Conservation Voters is a nonpartisan group that makes voters aware of how political candidates stand on environmental issues. The organization clearly needed to support its mission with printed materials that reflected its environmental stance.

Grafik Communications first developed a logo for the league that represents the group's mission by merging a leaf with a patriotic motif. From there, a comprehensive identity system was developed that married eco-sensitive materials with a patriotic look.

The identity system includes stationery and business cards printed on Simpson Birch, a recycled writing paper. The league's identity package also includes a folded 8½" x 11" sheet used to contain press releases and fund-raising materials. All of the pieces support the group's environmental mission in their minimal use of inks.

The folder was designed as an identifier, to wrap around rather than bind its contents. Using a folder to contain printed materials rather than binding them into a booklet saved binding costs, allowed the league to tailor the contents to individual mailings, and made the folder more easily recyclable.

The folder was printed in two colors on James River Grafika, 80# cover, a paper with 50% recycled content. The booklets, stationery and business cards were all printed with soy-based inks.

Design Firm: Grafik Communications Ltd.
Client: League of Conservation Voters
Design Team: David Collins, Susan English, Judy Kirpich
Illustrator: James Yang
Printers: Virginia Lithograph (folder), Huffman Press (stationery)

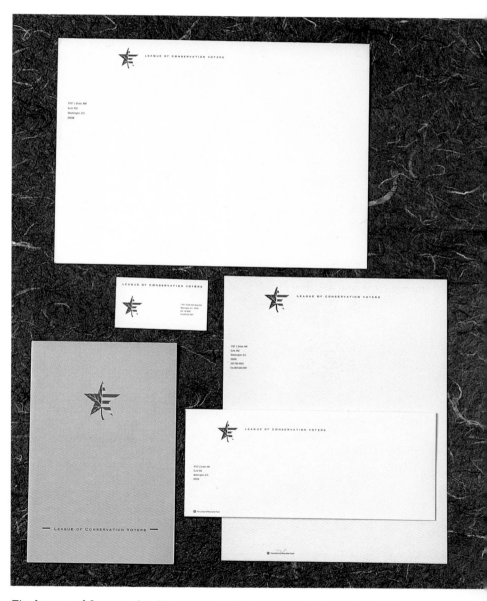

The League of Conservation Voters needed business materials produced with environmentally sensitive materials, but an earthy "granola" look was out of the question for this politically motivated group.

Letterpress is a printing process with many eco-friendly advantages: It generates less wasted paper, requires fewer press washes with toxic solvents, and eliminates the need for negative and platemaking when hand-set type is used. It also allows designers to print on a variety of materials not easily accommodated on a conventional offset press, such as industrial and handmade stocks.

Bruce and Karen Licher operate Independent Project Press (IPP), a letterpress shop in which both are involved in the design and printing of a variety of jobs. Known to many West Coast designers as "Mr. Chipboard," Licher has developed a following of clients seeking IPP's distinctive look—one that combines raw and unusual materials with the highly detailed, decorative ornamentation associated with antique metal type.

IPP's use of chipboard and other industrial stocks began when Licher first started printing. He experimented on shirt cardboard and other discarded scraps rescued from the trash and was immediately attracted to the board's color and texture as well as its budget-wise attributes. Licher's clients have responded to his choice of salvaged materials and their ecological advantages. Shown here are a number of business cards from IPP printed on a variety of eco-friendly papers.

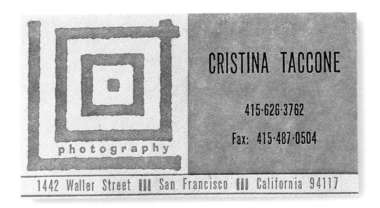

The graphic symbol on Christina Taccone's card is actually a printed letterpress ornament, substantially enlarged on a photocopier to give it a rough look. The card is printed on manilla tagboard, a stock normally used for file folders. The tagboard has a total recycled content of 50% and was purchased from a local distributor of fine printing papers.

Design Firm: Independent Project Press
Clients: Aurum Rose, Fuller Barnes, Miriam Kaplan, Cristina Taccone
Designers: Bruce Licher, Karen Licher
Printer: Independent Project Press

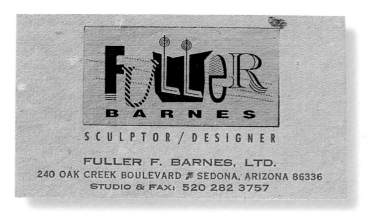

Fuller Barnes's business card is printed on French Dur-O-Tone, a 100% recycled stock that performs as well on an offset press as it does on letterpress.

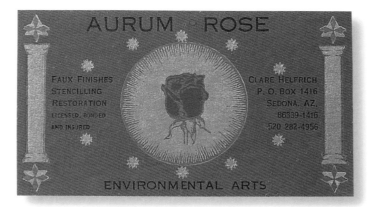

This business card for Aurum Rose combines a client-supplied illustration with rich metallics. The stock is railroad board, a 100% recycled stock purchased from Beveridge Paper Co. in Indianapolis.

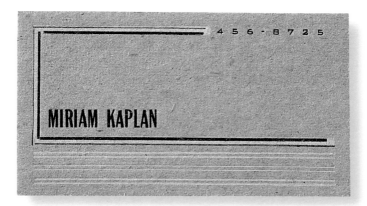

Miriam Kaplan's business card is printed on chipboard. No negatives or plates were used in the card's production—its design is composed entirely of metal type and borders.

Situated on the Waterfront, Seattle's trendy entertainment district, Italia combines an Italian restaurant, an art gallery, a catering service and a delicatessen within a single complex. When Italia's owners approached Hornall Anderson Design Works about designing a letterhead for the complex, they wanted to project a strong, colorful image on a limited budget.

The designers at Hornall Anderson Design Works were faced with the challenge of getting a big-color look for a small price. They decided to use just one match color and split fountains on an offset press to achieve the look of four colors. The technique yielded a rich palette of "edible" colors, including tomato red, olive and ochre.

Using split fountains conserved materials and labor by requiring just two sets of films and plates instead of four. The job was easily accommodated on a two-color as opposed to a four-color press, as well.

Hornall Anderson has made a policy of incorporating as many eco-friendly practices into its projects as possible. For this reason, the designers chose a recycled paper for the stationery, French Speckletone, with a recycled content of 80%. Soy-based inks were used on press.

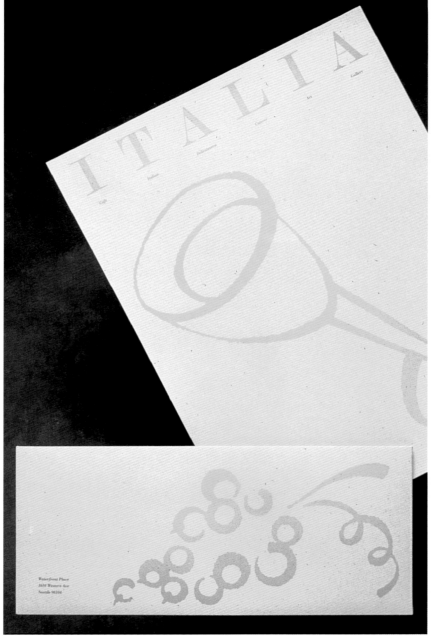

Italia's stationery was printed with a split fountain to convey the impression of four colors on a two-color press.

Design Firm: Hornall Anderson
 Design Works
Client: Italia
Design Team: Jack Anderson, Julia
 LaPine
Printer: Evergreen Printing

Blue Willow Tea Stationery

The Blue Willow Tea Company markets a wide variety of teas and custom blends, many of them organically grown. Although the company felt strongly committed to producing eco-sensitive packaging for their products, much of the impetus to extend that philosophy into the company's business papers came from its designers.

Sharon Mentyka and Stephen Schlott, principals of Seattle-based Partners in Design, have done much to raise eco-awareness among graphic designers in their region. They stress that early planning and discussions with clients and vendors are keys to successful results.

The Blue Willow Tea Company stationery exemplifies this approach. It's printed with a minimal amount of ink in two colors with vegetable-based inks on Neenah Environment, a 100% recycled stock with 15% postconsumer waste. Mentyka and Schlott chose two colors from the Environment line for the letterhead and envelope to give the impression of added color on a two-color run.

Schlott pointed out other advantages to using a darker-colored envelope. "It makes the letterhead seem brighter," he noted. This can be a real plus when trying to design with the darker tone of a "white" recycled paper that doesn't incorporate chlorine bleaching in its makeup. A darker envelope is also more likely to stand out amongst other mail.

"We also tend to not 'go fibrous,' " said Schlott, describing the paper his firm specs for letterhead. He said that the fibers in an "obviously recycled" looking paper can interfere with the legibility of the correspondence and will look dirty when photocopied. "With this compromise, we aim for high postconsumer content and non-chlorine-bleached stock," said Schlott. "With the envelope, you can do more rough-and-tumble stuff. Maybe the next time we run Blue Willow's envelopes, we can incorporate tea leaves into the pulp."

Design Firm: Partners in Design
Client: Blue Willow Tea Company
Design Team: Sharon Mentyka,
 Stephen Schlott
Printer: Litho House

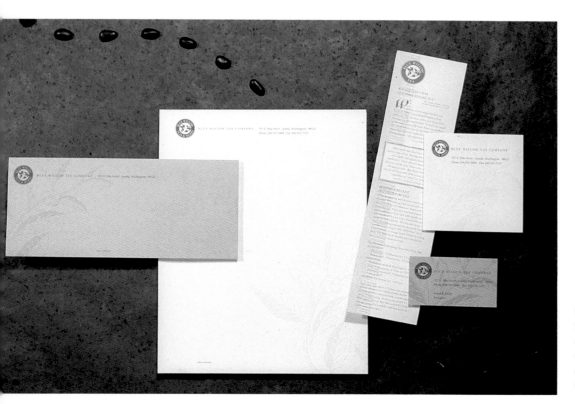

Blue Willow Tea Company's letterhead is printed on a non-chlorine-bleached 100% recycled stock. The letterhead appears brighter against the darker, coordinating envelope.

Design Firm: Werner Design Werks
Client: RadioActive Ink
Designer: Sharon Werner
Illustration: Sharon Werner
Printer: Togerson Printing, Quick
 Print, Custom Color

RadioActive Ink is an agency that specializes in writing radio advertising spots. When agency principals commissioned Sharon Werner to design identity materials for their firm, they wanted an image that projected the "on the edge" style of their work.

RadioActive Ink's clientele of ad agencies and radio personnel demanded a savvy, attention-getting image. Werner came up with a design that projects an appropriately "hazardous" look, but what gives the letterhead distinctive presence is its silver backing. Werner found the letterhead stock preprinted with solid coverage of silver ink on a web roll at a local paper warehouse. Werner had the warehouse trim the paper to letterhead size. The supply yielded enough letterhead for a run of 10,000, plus second sheets.

Because the warehouse overage was slated to be discarded, Werner not only salvaged the paper, but also saved her client money by purchasing used paper for less than what new paper would have cost. The only color required in the print run of the letterhead and envelopes was a medium blue ink and black, accomplished on a letterpress at Togerson Printing.

Werner's scheme for the design of RadioActive Ink's business cards and cassette wrapper is based on the silver and blue palette established by the agency's stationery. She chose French Dur-O-Tone with 100% recycled content for these materials. For added color, a yellow sticker was printed at a quick-print shop with Werner's version of the radioactive symbol. The black-and-yellow stickers give the business papers the look of a four-color run of yellow, black, blue and silver, but it was achieved at a fraction of the cost by printing the stickers as a one-color run of black on yellow label stock.

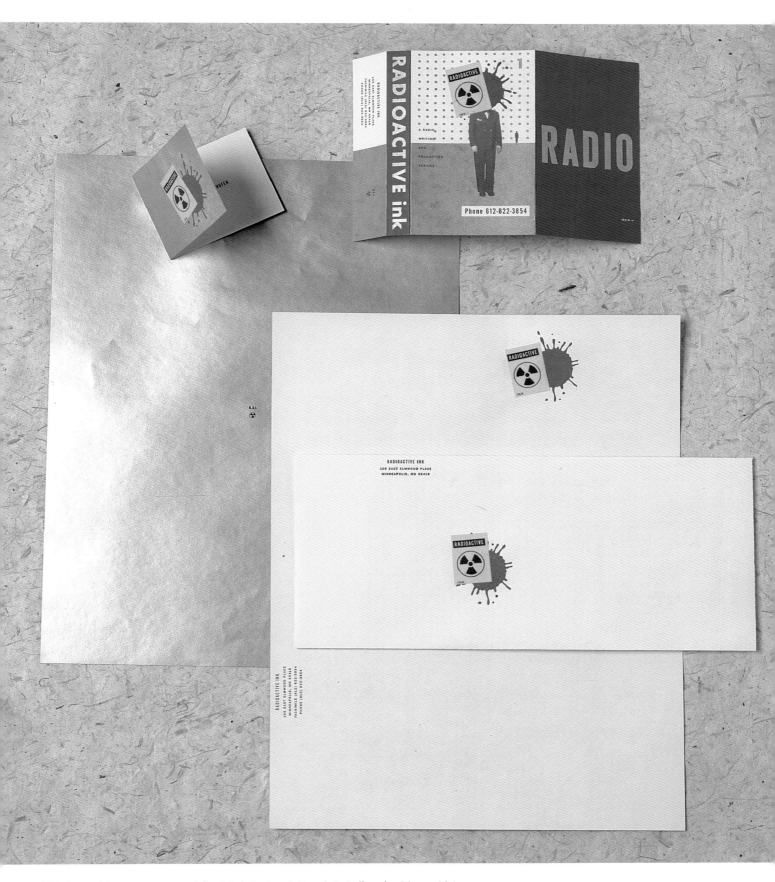

Unsalvageable paper was used for this letterhead. Its printed silver backing, which had made the paper unrecyclable, was perfect for the letterhead's color scheme.

Loews Hotels Stationery System

Design Firm:
 Lebowitz/Gould/Design, Inc.
Client: Loews Hotels
Design Team: Sue Gould, Susan
 Chait, Amy Hufnagel
Printer: Lehman Brothers, Inc.

Incorporating the "Loews stripe" as a watermark into the hotel chain's stationery allowed each hotel's identity to remain prominent.

The recycling process is always helped when designers limit the amount of ink they incorporate into their designs—ink that will ultimately need to be removed when the printed paper is recycled. Many designers try to minimize ink by opting for a blind emboss of a graphic image, especially when incorporating a logo into a stationery design, but few designers think of custom watermarking as an option. This approach is not only eco-sensitive—it can also yield a look of quality and understated elegance, as it did in this stationery program for Loews Hotels.

Lebowitz/Gould/Design, Inc. came up with the idea of incorporating a private watermark into Loews' hotel and guest stationery after developing amenities packaging for the hotel chain with Loews' signature mark—a subtle beige stripe. Although the stripe on the packaging is achieved by printing a tinted matte varnish on coated paper, translating this effect onto a writing paper required a different approach, but one which would be just as subtle.

The designers at Lebowitz/Gould contacted Gilbert Paper, one of a number of paper manufacturers that specialize in custom-watermarked writing papers. The huge volume of paper involved in providing stationery to all of Loews hotels allowed for a custom mix for the stationery paper. Because Loews Hotels is committed to maintaining eco-friendly standards, Gilbert technicians and the designers came up with a paper recipe that is a "special make" of Gilbert Esse. It includes 30% postconsumer waste and a total recycled content of 60%.

The stationery was printed with vegetable-based inks that were heat-sunk for laser compatibility.

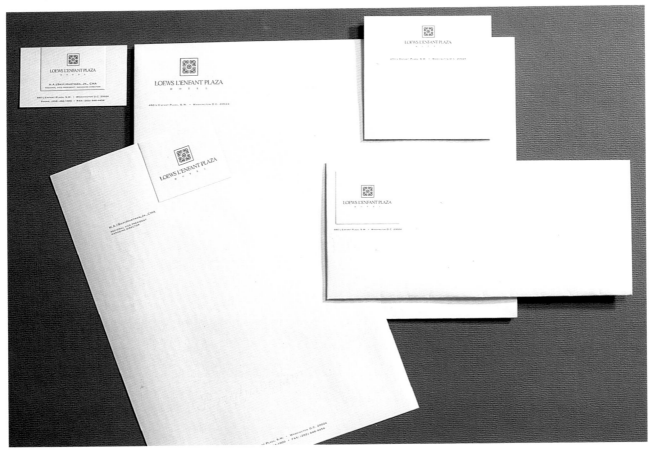

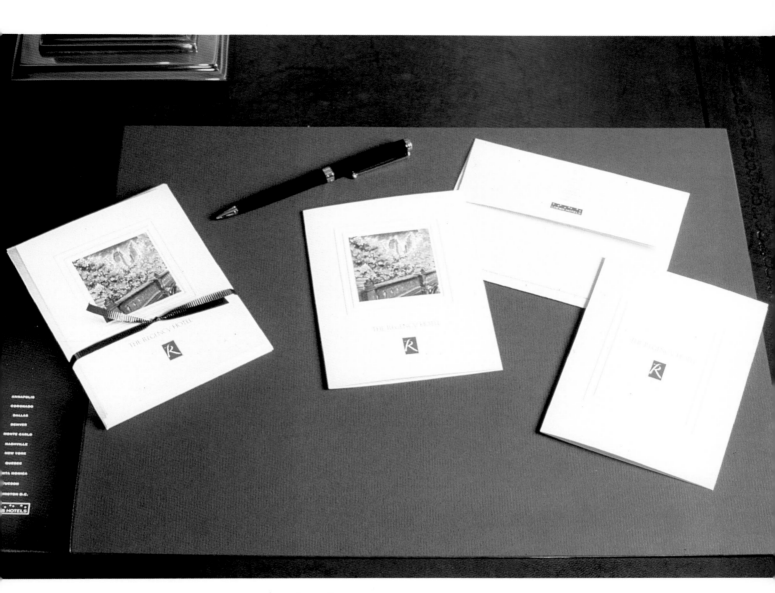

The Loews stationery program includes seventeen items from
letterhead and business cards to telephone and conference pads.
Guest room cards were also created, featuring a pastel illustra-
tion embodying the character of each hotel. These cards, along
with their watermarked envelopes, are in all guest rooms
throughout the chain.

Ecodea Self-Promotional Brochure

Design Firm: Richardson or
 Richardson
Client: Richardson or Richardson
Design Team: Forrest Richardson,
 Valerie Richardson, Diane
 Gilleland
Printer: McGrew Printing

"Our industry creates a lot of junk," admitted Forrest Richardson, cofounder with wife Valerie of the award-winning design firm Richardson or Richardson. "We need to create stuff people will want to keep or stuff that has minimal impact on the environment if thrown away."

Richardson or Richardson has acted on this belief by forming Ecodea, a division of the firm that consults with clients on environmentally sound ways to position and market their products and services.

Ecodea goes far beyond recommending soy-based inks and recycled papers. The Richardsons work instead at developing alternative solutions to paper-intensive direct mail marketing campaigns and other promotional strategies that create unnecessary waste.

In one instance, the Richardsons recommended that a construction company scrap a mail campaign directed at 6,000 medical-group prospects in favor of a strategically targeted mailing to fifty of its most likely prospects. The mailer Richardson or Richardson conceived, which included x-rays of carpenter's tools, made more of an impact on its audience and saved materials as well as money.

Ecodea's self-promotion is symbolic of the firm's commitment to the environment. Made of industrial chipboard, the letterpress-printed booklet is no larger than a business card, yet expresses the firm's mission powerfully with its humble but elegant design. Using the letterpress's hand-set type eliminated the need for press plates or negatives. The booklets were then hand-stamped with a variety of circular symbols. The different colored symbols give the piece the look of a multicolor run at a fraction of what it would have cost. Forgoing a multicolor run also kept ink to a minimum—an aspect that will aid in the deinking and recycling process of the piece when it is finally discarded. Binding the piece with a screw set eliminated the need for glue or plastic binding.

Ecodea's self-promotional brochure is symbolic of the firm's eco-conscious mission in its use of letterpress type and rubber-stamped images on industrial chipboard.

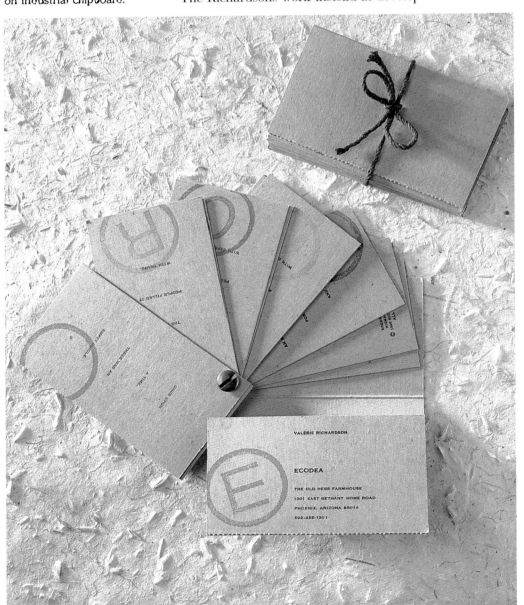

Gilbert ESSE Sales Kit

This promotional sales kit for Gilbert Paper's line of recycled papers carries off its eco-friendly theme with photos of mobiles made from sticks, seed pods, leaves and other objects you might find on a walk in the woods. Used by Gilbert's sales representatives to show off its ESSE line, a recycled paper with a 60% recycled content, the kit's environmental theme made eco-worthy production techniques and natural materials a necessity.

The modular sales kit contains a variety of items—among them cassette tapes, swatch books and a brochure—which vary according to the representa-

tive's needs. Grafik Communications Ltd. decided to contain the swatch books in a box made from E-Flute, an industrial-grade corrugated cardboard. To further enhance the eco-friendly theme, the kit was secured with a closing made from jute twine and wooden twigs. (The twigs were actually collected in the woods by designer Betsy Thurlow-Shields who broke them down to the size needed. Nearly three hundred twigs were needed for the job!)

The four-color labels affixed to the outside and interior of the box were printed with soy-based inks on a standard offset press.

Design Firm: Grafik Communications Ltd.
Client: Gilbert Paper
Design Team: Melanie Bass, Gregg Glaviano, Judy Kirpich
Photographer: Claudio Vazquez
Copywriter: Jake Pollard
Printer: VA Lithograph
Sculptures: Betsy Thurlow-Shields

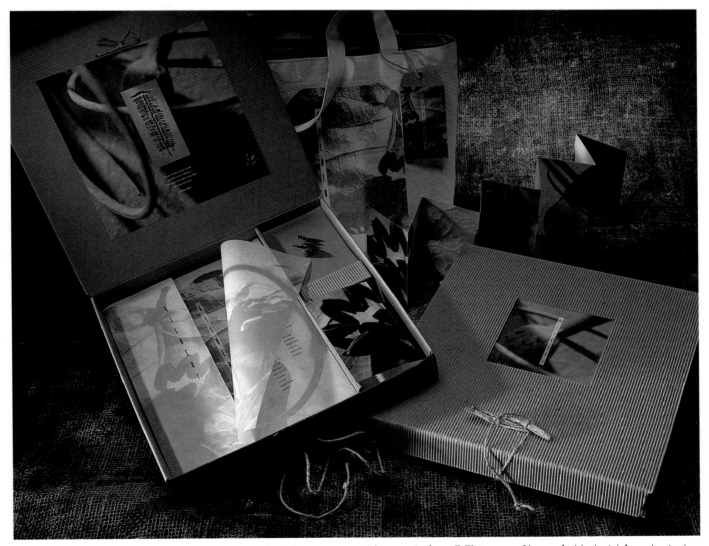

Gilbert Paper's sales kit for its ESSE line is contained in a corrugated box made from E-Flute, a 100% recycled industrial-grade stock.

Design Firm: Little & Co.
Client: Cross Pointe Paper
 Corporation
Creative Director: Paul Wharton
Designer: Tom Riddle
Photographer: Claudio Vazquez
Copywriter: Art Novak, Art of
 Copy
Printer: VA Lithograph
Sculptures: Betsy Thurlow-Shields

This paper promotion for Cross Pointe Paper Corporation's Genesis line of recycled papers serves many purposes. At first glance, the 11" x 17" promotion appears to be a booklet, secured in one corner with a grommet. However, each page is actually a 34" x 11" poster folded in half (so that the fold is on the outer edge of each page). The promotional copy and production information on the back of each poster is the first item to be seen, but when each page is unfolded, a four-color poster is revealed.

Printed on a variety of weights and colors to demonstrate how well the paper performs on press, each of the eight posters was created by a well-known illustrator or photographer. Themes for the posters focus on attributes often associated with the word "natural" such as talent, beauty and light. Perforations at the top edge of each poster and the cover encourage promotion recipients to tear them off.

When the cover and posters have been removed, the promotion becomes a swatch book of bound chips of paper, each labeled with its finish, weight and color. Designer Tom Riddle pointed out that because Genesis is composed of 100% recycled postconsumer waste, it was crucial to reinforce this message with a promotion that could be used for other purposes. "The entire piece is meant to be recyclable," he said.

Given the promotion's theme of recycling, it was only "natural" for Riddle and the other designers to forgo hard-to-remove production techniques such as foil-stamping and thermography so that when the promotion is finally discarded, the paper can be easily deinked.

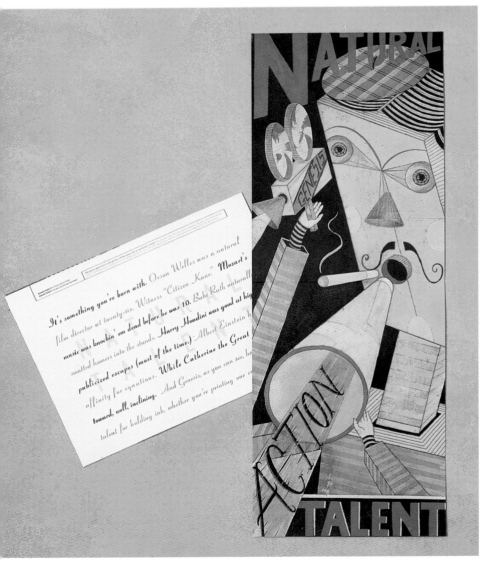

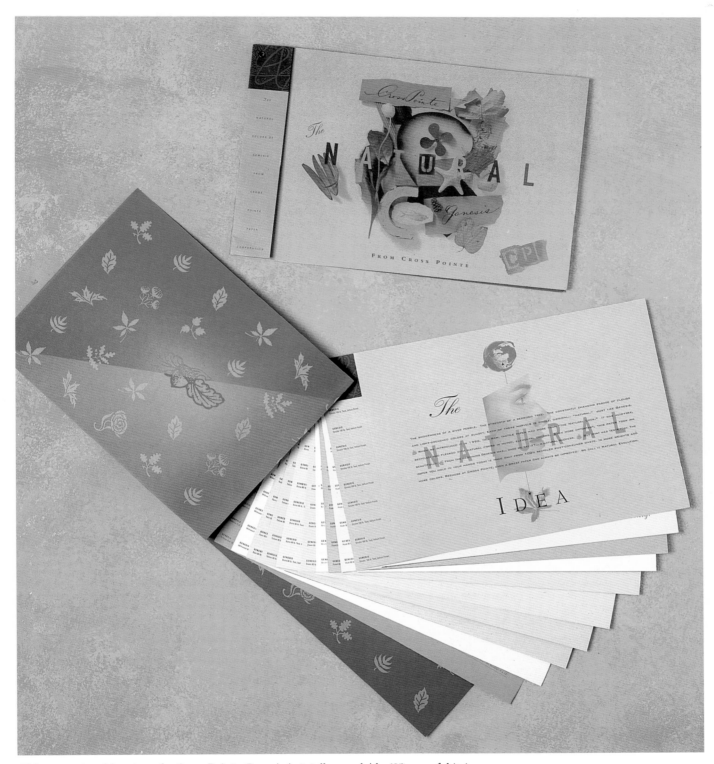

This promotional brochure for Cross Pointe Genesis is totally recyclable. When unfolded, its cover and pages become posters. The promotion becomes a swatch book when the posters are removed.

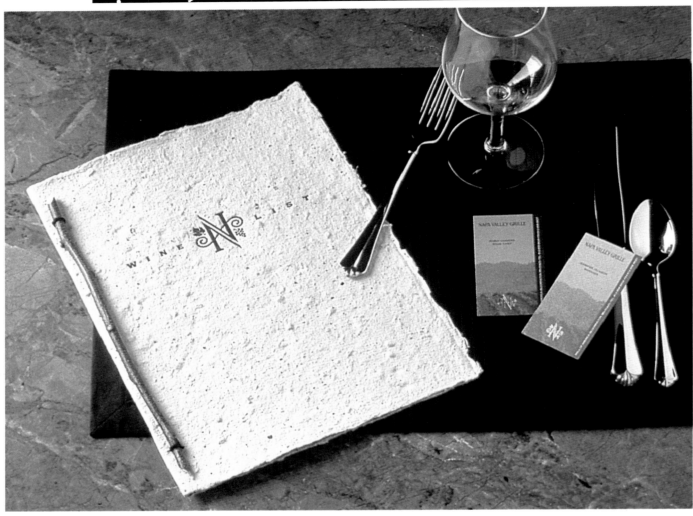

This wine list cover is a conversation starter and a tree saver—it's made entirely from grape fibers, skins and seeds.

Design Firm: Tharp Did It
Client: California Cafe Restaurant
 Corporation
Design Team: Rick Tharp, Colleen
 Sullivan
Printer: Evanescent Press
Papermaker: Evanescent Press

The Napa Valley Grille restaurants, located in the Mall of America in Bloomington, Minnesota, and in Napa Valley, California, have a wine list cover that their patrons immediately notice. Its distinctive texture and wine-colored tint are unlike any other paper.

The wine list cover also saves trees. It's constructed from paper made entirely from a renewable resource—grapes. Upon closer scrutiny, one can actually see the grape fibers, skins and seeds that went into the composition of this unusual hand-made paper.

The heavy texture of the paper eliminated the possibility of printing the covers on a conventional offset press. The small run of four hundred made letterpress an appropriate option for the job. The letter-pressed type and logo add a rustic look, and the stamped relief impression adds another dimension to the cover.

Designer Rick Tharp has made a habit of incorporating as many environmentally friendly practices as feasible into his firm's jobs. One of the reasons he opted for letterpress is because it uses fewer pre-press chemicals than conventional printing and wastes less paper.

The wine list is bound by looping twine through two holes around a grapevine stick, then securing the twine with a knot in the back. The wine list is always up-to-date because reprinted inserts (printed on a recycled stock) can be handbound easily into each cover.

Hornall Anderson Holiday Card

Sending holiday cards to clients is good business and a good opportunity for design firms to showcase their work. Hornall Anderson Design Works has made a practice of sending a holiday card every year, but the 1993 holiday season found the firm swamped with client projects and putting off the task of designing its own holiday card.

With Christmas less than three weeks away, the designers at Hornall Anderson put their heads together, brainstorming ideas that would allow them to produce five hundred cards at a reasonable cost within a two-week time frame. Designers Jack Anderson and Mary Hermes came up with the idea of producing a card from leftover papers from previous jobs and unused items in their studio. The papers they decided to use for the card were swatches of Confetti, a 100% recycled paper in a Christmasy red; UV Ultra II, a translucent vellum; and corrugated cardboard that a paper company had provided as a sample roll.

This interesting combination of papers was trimmed and torn in a variety of shapes to give the card a spontaneous, unlabored look. The papers were hand-assembled into cards by tieing the three layers of paper together with raffia. The interesting contrast of textures and shapes gave the cards a distinct personality and eco-conscious look that tied in with the "resourceful" theme.

In keeping with the card's eco-friendly message, printing was kept to a minimum—the Hornall Anderson logo was blind embossed on a letterpress. The holiday message, in black ink, was also printed on a letterpress.

Design Firm: Hornall Anderson
 Design Works
Client: Hornall Anderson Design
 Works
Design Team: Jack Anderson, Mary
 Hermes
Printer: Graphic Impressions

Designers at Hornall Anderson Design Works were extremely "resourceful" in conceiving a holiday greeting card that made use of leftover materials.

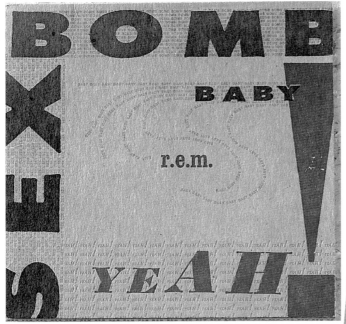

This holiday record jacket for R.E.M. was letterpress printed in gold, green and brown on industrial chipboard.

Musician and designer Bruce Licher and his wife Karen run a Sedona, Arizona-based letterpress printing shop called Independent Project Press. Among IPP's numerous jobs are compact disc and record packaging that Licher designs and prints himself for fellow musicians, often using environmentally sensitive materials such as industrial chipboard.

In 1989 the rock band R.E.M. asked Licher to do a holiday card for fans and industry professionals. "Michael Stipe, their lead singer, has always been interested in environmental causes," said Licher. "He had seen our work and liked that we used chipboard." Since then, IPP has done four holiday projects for R.E.M., including the 1994 holiday promotion shown here. This mailing consisted of a chipboard record sleeve containing a 45 RPM recording done especially for the fan club and a holiday card—all sent in a stay-flat mailing carton also made from chipboard.

The graphics on the seven-inch record sleeve represent the two songs on each side of the record it contains. The "Sex Bomb Baby" side was designed using a combination of old metal type and digitally set type. The chipboard sleeve was constructed without glue so it can easily be deinked and recycled.

Although the metal type and borders Licher used on his letterpress eliminated the need for creating negatives or metal plates when used alone, it was still necessary to burn a plate that included the stamp imagery and digitally set type as well as the sleeve's other design elements. Nevertheless, letterpress printing is more eco-friendly than conventional offset because fewer toxic solvents are needed for press washups. The process also generates fewer impressions per minute and results in less wasted paper due to spoilage.

The holiday card and mailing carton for R.E.M.'s 1994 holiday promotion, sent to members of its fan club, were made from industrial chipboard like the record sleeve.

Design Firm: Independent Project
 Press
Client: R.E.M.
Designers: Bruce Licher, Karen
 Licher
Printer: Independent Project Press

Designers of pieces that promote events and causes often assume that bigger is better when getting their message across. They'll opt for a flashy poster with the idea that its large-scale format is more likely to be noticed. There are instances, however, when a strategically placed flyer can be more effective than a poster.

On the fifth anniversary of the Iranian decree calling for the death of British writer Salman Rushdie, Drenttel Doyle principal Bill Drenttel was asked by the Rushdie Defense Committee to help in the effort to free the writer from condemnation. Drenttel was asked to conceive a means of printing and distributing a state-

ment of support for Rushdie. Initially, the committee thought the statement could best be dispersed with a poster that would be displayed in bookstores across the country, but to create a more intimate and powerful experience for readers, Drenttel and partner, Steven Doyle, decided instead to design a flyer that could be inserted in books sold on February 14th, the anniversary of the Iranian decree.

The flyers were printed on one side on Champion Directory, a 24# bible-weight stock typically used for printing dictionaries, encyclopedias, and other books of many pages. The insert was folded in half, and then folded again, to a 4⅜" x 7¼" flyer that fit neatly beneath the cover of paperback and larger-format books.

The effort, organized by writer Paul Auster, editor Nan Graham, Bill Drenttel, and Oren Teicher of the American Booksellers Foundation for Free Expression, involved four thousand participating bookstores. A total of 450,000 inserts were printed and distributed across the United States.

Sometimes a strategically placed flyer gets a message across more effectively than a poster. This book insert also makes economical use of paper.

Design Firm: Drenttel Doyle
 Partners
Client: Rushdie Defense Committee
Designer: Steven Doyle
Writer: Don DeLillo
Printer: Red Ink Productions

Sometimes a client dictates an environmentally sound approach in the development of its brand identity, but it often falls on the designer to come up with an eco-friendly design that, at the same time, fulfills the communication objectives of the client.

In the case of developing an identity for 3M Patient Comfort System, Brian Collins, principal of The Brian Collins Studio, wanted to conceive an eco-sensitive system from the onset. The project involved developing a comprehensive packaging system that would incorporate product packaging, instructional materials and shipping container for a new dental product that eliminates the need for needle-injected painkillers. Collins's goal was to come up with a concept that met these objectives and made efficient use of eco-friendly materials.

Collins chose to print product information that would periodically change on 8½" x 11" sheets of French Dur-O-Tone bound in a ring binder. The binder not only allows for interchangeable inserts, it also can withstand frequent use by dentists who refer to it often, and it can eventually be used for other purposes when the inserts are no longer needed.

The binder was encased in a corrugated holder that also contains patient literature, an educational video and the product. The holder and outer shipping container were made from a corrugated board faced with a non-chlorine-based substrate. The surface of the board produced brilliant color and crisp detail on a conventional offset press. Vegetable-based inks were used on all of both containers and the binder inserts to produce a multicultural color scheme.

Design Firm: The Brian Collins
 Studio/Minneapolis
Client: 3M
Designer: Brian Collins
Illustrator: Brian Collins
Printer: B.F. Nelson

The promotional materials and packaging that make up this identity system were all produced with vegetable-based inks.

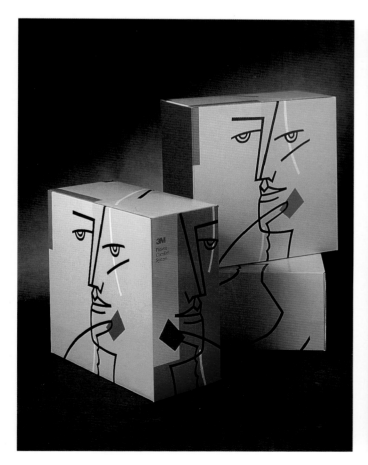

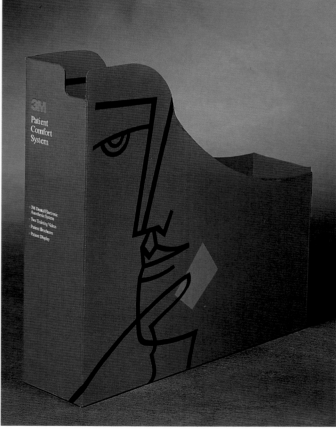

Starbucks Coffee Company is a multi-million-dollar business and one of the nation's most recognized and successful premium coffee roasters. The company has been enormously successful in its combined food service and coffee retailing establishments.

In recent years, Starbucks decided to update its image to visually reflect the company's commitment to quality and freshness. Starbucks' shopping bag exemplifies the company's updated brand identity. Conceived by Hornall Anderson Design Works, it uses warm colors, steam patterns, the Starbucks logo and intimate illustrations to convey the company's mission of providing quality products in a warm and intimate atmosphere. The same look is carried into Starbucks' product packaging and store fixturing.

Because Starbucks markets an organic product and takes measures to conserve and recycle in many areas of its operation, it was important to produce the Starbucks bag in an eco-friendly manner. The bag's color palette consists of ochre, terra-cotta, kraft brown and celadon green. The colors are used on all of Starbucks' product packaging to convey a warm, rich image and to aesthetically support Starbucks' mission of environmental responsibility.

In keeping with Starbucks' eco-conscious policies, the kraft bags were printed with a flexographic process using water-based inks.

Starbucks' shopping bag is made of industrial kraft paper and printed with water-based inks.

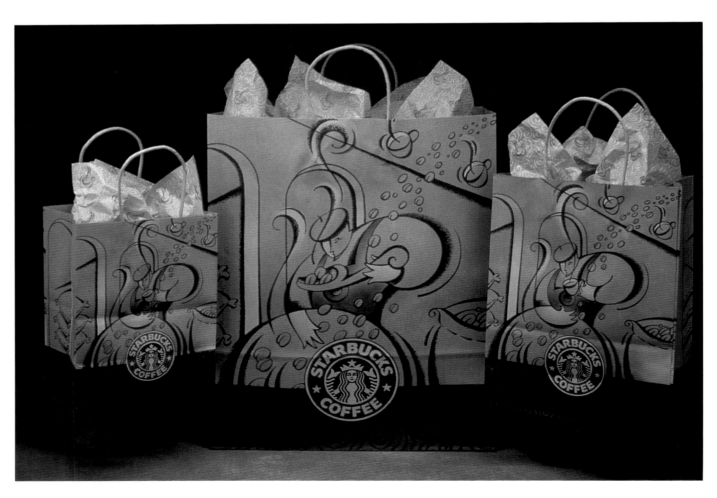

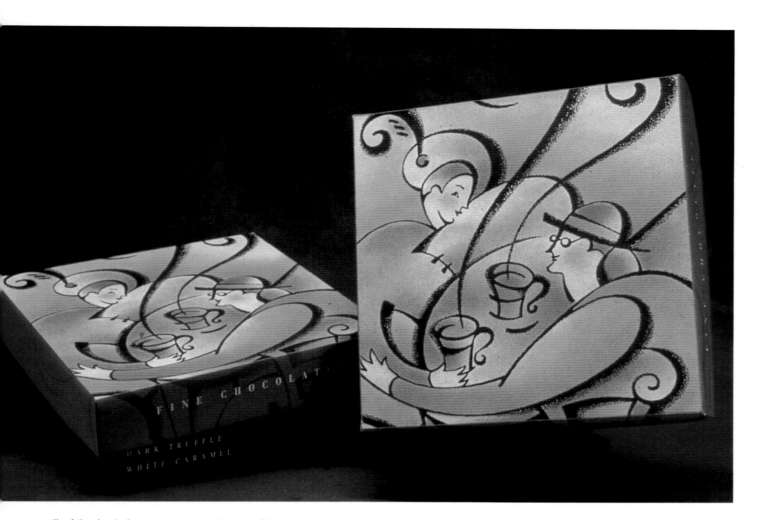

All of Starbucks' products are packaged with eco-friendly materials and an earth-toned color scheme.

Design Firm: Hornall Anderson
 Design Works
Client: Starbucks Corporation
Design Team: Jack Anderson, Julie
 Lock, David Bates
Illustrator: Julia LaPine
Printer: Duro Paper and Plastics

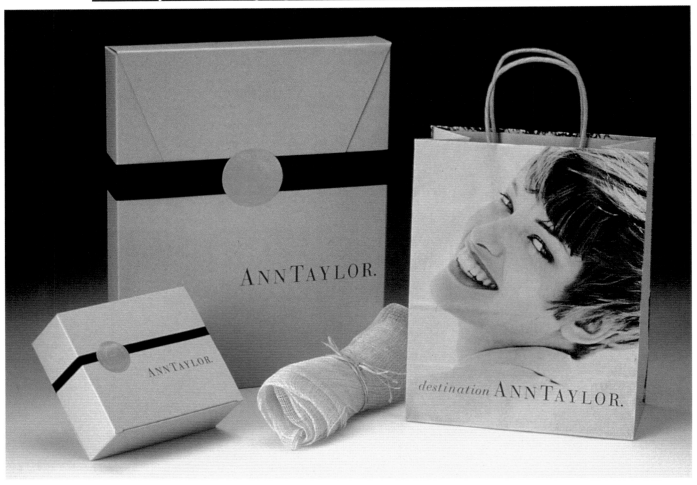

In keeping with Ann Taylor's policy of using natural materials wherever possible, the gift packaging shown here with the Ann Taylor shopping bag uses 100% cotton grosgrain ribbon and a paper seal.

Ann Taylor has made a practice of incorporating eco-sensitive materials into its packaging and in-store fixturing, a practice that supports its natural image. New York City-based Desgrippes Gobé & Associates has worked extensively with Ann Taylor to develop a brand identity that combines a spare, sophisticated look with eco-friendly methods and materials.

The Ann Taylor shopping bag that features the smiling Ann Taylor woman exemplifies the measures Desgrippes Gobé has taken to develop design solutions that are in keeping with the retailer's eco-friendly image. "We tried to construct it in a sturdy way so it can be reused," said designer Peter Levine regarding the bag. "They always want us to create packaging that's reusable."

Ann Taylor did considerable research to determine what size shopping bag would be reused most frequently by consumers and discovered that the 9" x 12" was the size that would most likely be put to further use. Levine points out that this size is especially handy for the second pair of shoes many women tote to work to wear in place of the athletic shoes they commute in. The bag is a mobile ad for Ann Taylor as it's used to tote shoes, lunches and other items.

Not only is the reusable shopping bag smart billboarding, it exemplifies the use of environmentally sound materials in its use of a custom-made, industrial kraft paper with a high recycled content.

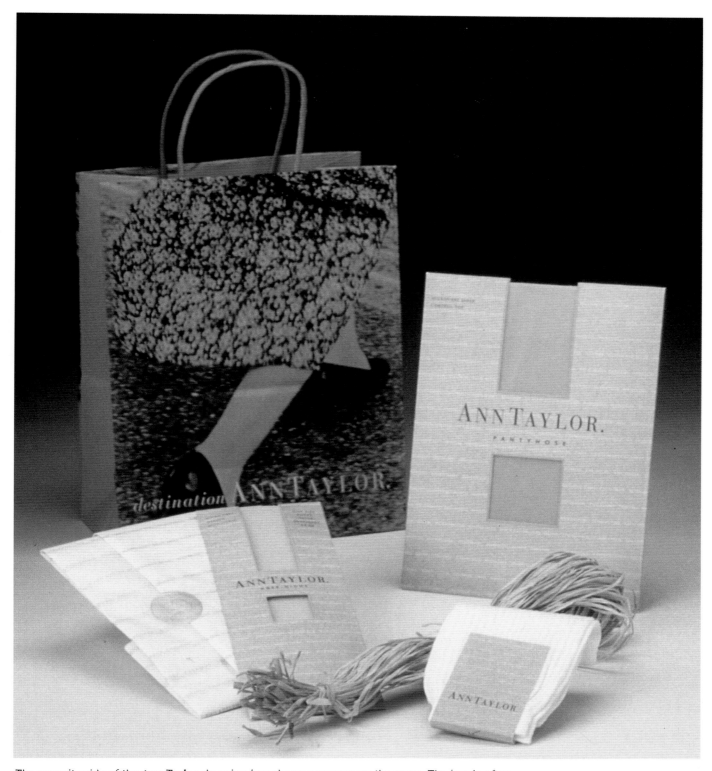

The opposite side of the Ann Taylor shopping bag shows a woman on the move. The bag is often used when shoppers purchase Ann Taylor hosiery.

Design Firm: DesGrippes Gobé & Associates
Client: Ann Taylor
Design Team: Marc Gobé, Peter Levine
Photographer: J.R. Durand
Printer: Wright Packaging

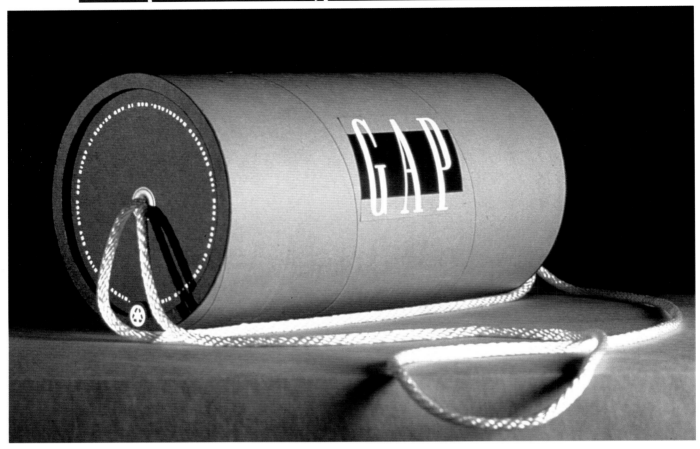

Made of recycled materials, the Gap shoe box prototype can be reused as a tote.

The Gap, a nationwide chain of clothing stores, was in the process of researching its retail shoe market when it retained Rick Tharp of Tharp Did It as the graphic designer for its shoe packaging. The Gap realized it had a problem with its existing packaging of traditional shoe boxes stacked on shelves. Customers would remove a box from the shelf, try on shoes, open another box and try on shoes, and so on. Eventually, shoes ended up in the wrong box, and the boxes were shoved back on the shelf in the wrong location. Tharp was asked to develop a packaging concept that would help the Gap with its inventory organization.

Tharp and his staff came up with a color-coded point-of-sale system that works much like a soda can vending machine. The tubular shoe boxes are stacked in a slat-wall dispenser which allows the bottom package to be removed while another drops into place. The system allows for a neat, self-stacking and orderly return of handled merchandise.

Tharp's prototype for the shoe box is as eco-friendly as he could make it: kraft wrap tubes, a 100% recycled material, and snap-on lids made of recycled blow-molded polyethylene. Even the Gap label is printed on a recycled label stock. The shoe box is not only sturdy and recyclable—a cotton rope strung through the tube encourages customers to reuse it as a tote after the shoes have been purchased and removed.

At the time Tharp designed the shoe box, The Gap was not fully committed to entering the shoe business. A re-evaluation of their self-serve shoe business put the project on hold indefinitely.

Design Firm: Tharp Did It, for
 Rofu
Client: The Gap
Designer: Rick Tharp

Candinas Chocolates Packaging

andinas, manufacturer of fine chocolates, has taken measures to incorporate environmentally kind practices into its business. Because its products contain no preservatives, Candinas wanted to project this purity with the organic look of eco-friendly packaging made of 100% recycled materials. The chocolatier also wanted its packaging to convey a sense of high quality and richness.

Planet Design conceived a packaging concept based on a raw, natural-looking interior box that fits neatly into a printed slipcase. Printed in three colors on Yellow Fox River Confetti, a 100% recycled stock, the slipcase eliminates the need for an outer wrapper of paper or cellophane. The slipcase also carries the Candinas logo and establishes the chocolatier's brand identity.

The interior box is constructed of French Dur-O-Tone, a 100% recycled stock with the look of industrial chipboard. The embossed relief impression of the Candinas logo on the slipcase is reinforced with a blind emboss of the same logo on the lid of the interior box. A folded insert, also constructed of Confetti, keeps the chocolates secure for shipping and handling. The interior wrapper is printed with the Candinas name on Curtis Patapar, a parchment paper that fulfills FDA requirements for paper-to-food contact.

Printed with vegetable-based inks, the Candinas box stands out among its glitzy, gold-foil-wrapped competitors with its natural, eco-friendly packaging. The unique contrast of materials and textures works to project a look of quality and richness as well as a wholesome, organic look.

The unique contrast of textures and eco-friendly materials used in the design of this chocolate box works to project a sense of wholesome quality and richness that sets this packaging apart from its glitzy competition.

Design Firm: Planet Design
 Company
Client: Candinas Chocolatier
Design Team: Kevin Wade, Martha
 Graettinger, Dana Lytle
Printer: American Printing Co.,
 Madison Cutting Die,
 Diversified Graphics

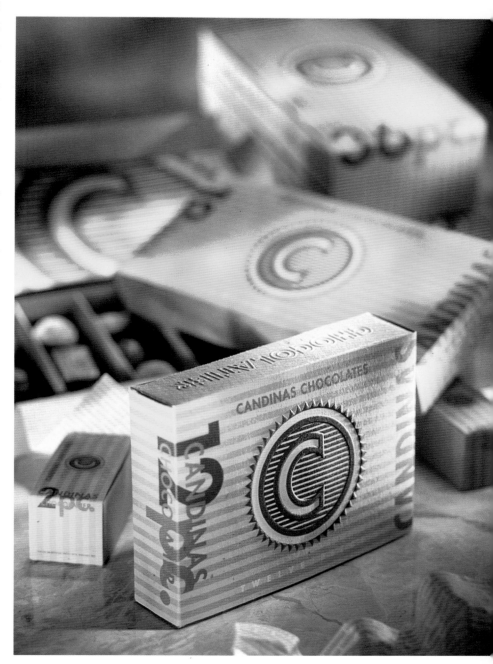

Design Firm: Charles S. Anderson
 Design Co.
Client: CSA Archive
Design Team: Charles S. Anderson,
 Todd Hauswirth, Paul Howalt,
 Eric Johnson

With his distinctive promotions for French Paper, designer Chuck Anderson champions a unique style that is highly visible in the design community. His frequent use of vernacular images and classic typefaces created such a demand for his art that it prompted Anderson to form a spin-off business of products bearing this design approach.

Under the CSA Archive banner, Anderson markets a line of watches and pins bearing the design style he popularized. These products are packaged in tins reminiscent of an era when products were packaged in sturdy, natural containers. Their sense of utility enhances the look of Anderson's products.

More important, the tins project an archival look that gives them instant status as keepsakes. Their sturdiness and handy size, useful for storing and organizing jewelry and other small items, also help ensure they will be reused rather than discarded. The tins, with their snap-on lids, were a stock item purchased from a vendor specializing in metal containers. The tins themselves aren't printed; their letterpress-printed labels can be removed, allowing consumers to affix their own labels if they desire. The tins also make efficient use of resources, requiring no seals or shrink-wrap.

left
CSA Archive wristwatches come in tins that complement the watches' subtle humor.

right
In addition to storing fifteen interchangeable magnets that mix and match to create a variety of faces, the Magnetic Personalities magnetized steel tin is also designed to stand on its own to display face creations.

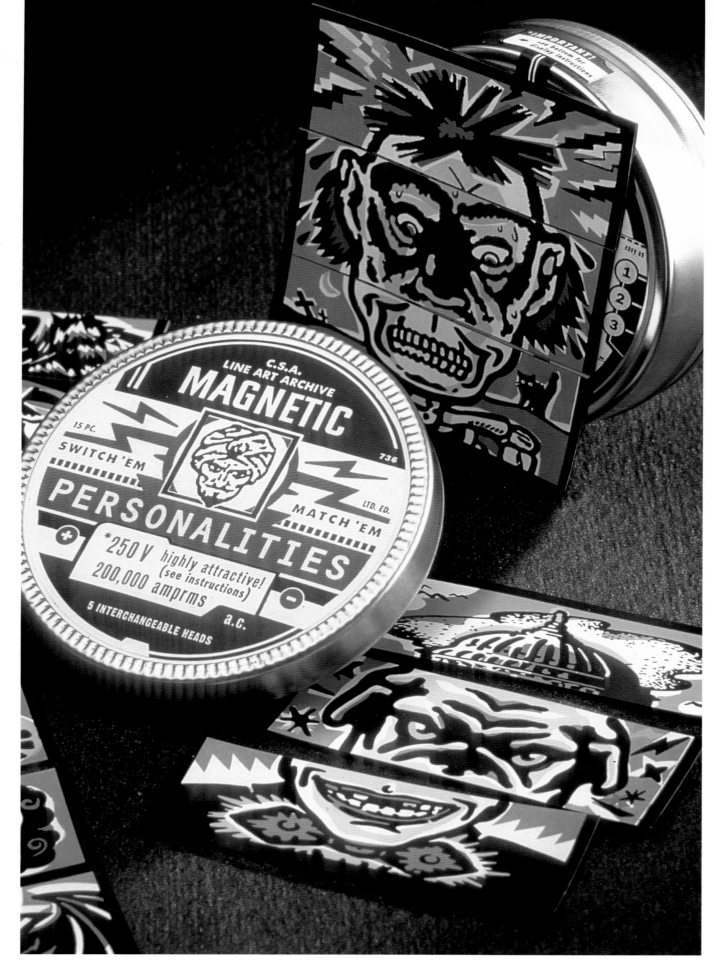

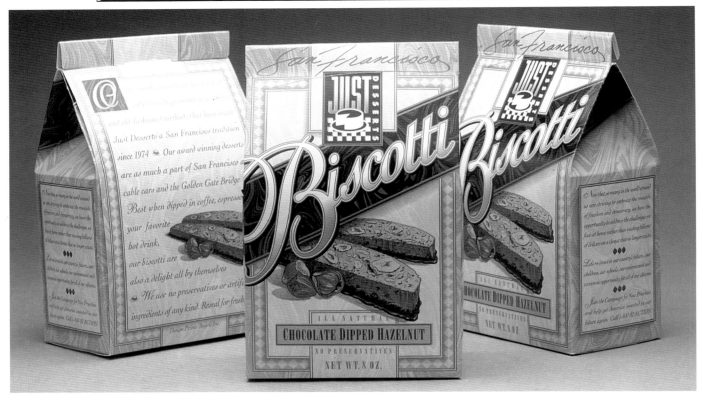

Just Desserts' biscotti packaging supports the company's eco-friendly image.

Design Firm: Primo Angeli, Inc.
Client: Just Desserts
Art Director: Primo Angeli
Designer: Philippe Becker

Just Desserts is a San Francisco-based bakery with several retail outlets in the local area. When the company approached Primo Angeli, Inc. for a package design, they wanted to market a biscotti line that would sell in retail outlets beyond Just Desserts stores. Because Just Desserts uses no artificial ingredients or preservatives in its baked goods, the company wanted to project a pure, natural image. The bakery also maintains a high profile in the San Francisco community, sponsoring area events and environmental causes, so they needed an eco-friendly look that supported this image.

"The nature of the product required an interior bag of cellophane to keep it fresh," said designer Philippe Becker. For shelf impact and to protect the product, Becker and creative director Primo Angeli decided to encase the cellophane-wrapped biscotti in an outer carton made from clay-coated chipboard, an industrial stock that breaks down easily in the recycling process. Although white paperboard is more commonly used in packaging, the design team decided to avoid it because of its association with bleaching agents that cause dioxins. They chose brown chipboard instead for its eco-friendly look. The chipboard box was printed in four-color plus gold metallic ink on an offset press.

The carton is tapered, much like a bag. Its assembly and ingenious self-closure require no adhesives or fasteners that would inhibit its biodegradability. "We used materials that were essential and nothing more," explained Angeli. "If you use reusable materials and come up with a well-engineered design solution, the environment will usually be taken care of with no sacrifice or loss of profit to the manufacturer."

As an alternative to the typical bakery box with a cellophane window, or box with plastic cookie tray, the biscotti package establishes a strong shelf presence in an environmentally kind manner.

Loews Hotels Guest Amenities

When Loews Hotels approached Lebowitz/Gould/Design, Inc. about designing a packaging program for its guest amenities, the hotel wanted an upscale look that conveyed a message of "special attention." A variety of bath and grooming products were involved, all to be packaged in a consistent manner. In addition to projecting a sophisticated and cohesive image, the hotel chain also wanted the packaging concept to be as eco-friendly as possible.

The Lebowitz/Gould/Design team came up with a brand identity for the amenities packaging that employs a subtle stripe achieved with a tinted varnish. The fashion-savvy stripe imparts a distinctive, deco-look to all bottle labels, boxes and wrappers.

The stock the designers selected for the boxes is Champion Krome Kote 2000, a recycled cast-coated paper with 50% recycled content. The designers spec'd a .010 label weight of Krome Kote 2000 for the bottle labels. Because a portion of the packaging production was done in Hong Kong, vendors there were given samples of the Champion stock to match to locally available paper.

Bottles were custom designed by Lebowitz/Gould/Design to color coordinate the wrappers and boxes. The designers decided to have them manufactured in recyclable clear PET plastic. PET (polyethylene terephthalate) is a plastic that has a low combustion point and doesn't emit toxic gas when burned, making it easy and safe to incinerate.

Design Firm:
 Lebowitz/Gould/Design, Inc.
Client: Loews Hotels
Design Team: Sue Gould, Susan
 Chait, Amy Hufnagel
Printers: Hewitt Soap

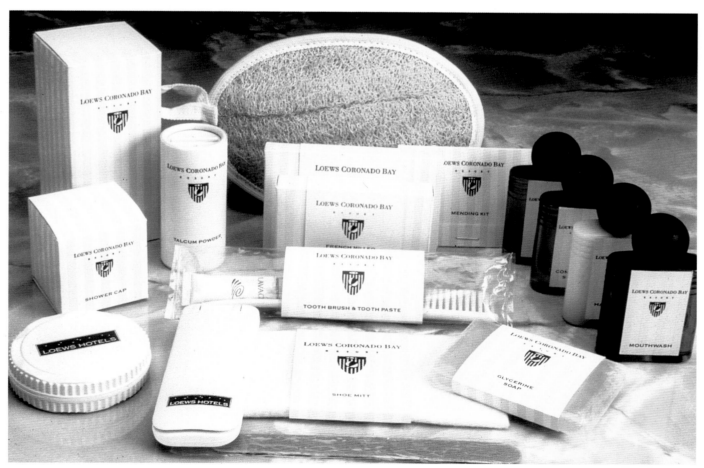

Guest amenities packaging for Loews Hotels achieves an upscale look on stocks with a high recycled content.

When Mariani decided to repackage its line of dried fruit, the company's executives brought several objectives to the table. "First of all, they wanted a more upscale, proprietary look for a stronger shelf image," related designer Carlo Pagoda of Primo Angeli, Inc. Mariani also wanted a design that conveyed the freshness of its product, and to preserve this freshness they wanted a resealable container. The design team and Mariani were in agreement on a design that made economical use of materials and encouraged recycling.

Mariani's previous package was a plastic bag that lay flat on the shelf. Packaging the product in a resealable bag within a rigid, cardboard box would have given Mariani products more shelf impact than a limp plastic bag, but the concept would have involved excessive packaging. The design team decided instead to use a stand-up plastic bag with a gussetted bottom, so the bag can stand without the support of a cardboard box.

The resealable closure on the Mariani bag encourages consumers to reuse the bag for general storage of other foods after the contents have been emptied.

Mariani introduced its new packaging about two years ago. Since then, sales of its products have nearly tripled, all because of the new design. "You've got impact, taste appeal and billboarding working together, and it's a simple container," said firm principal Primo Angeli, "There's nothing between the container and the product."

The Primo Angeli design team developed three versions of the bag, one for each of Mariani's dried fruit products.

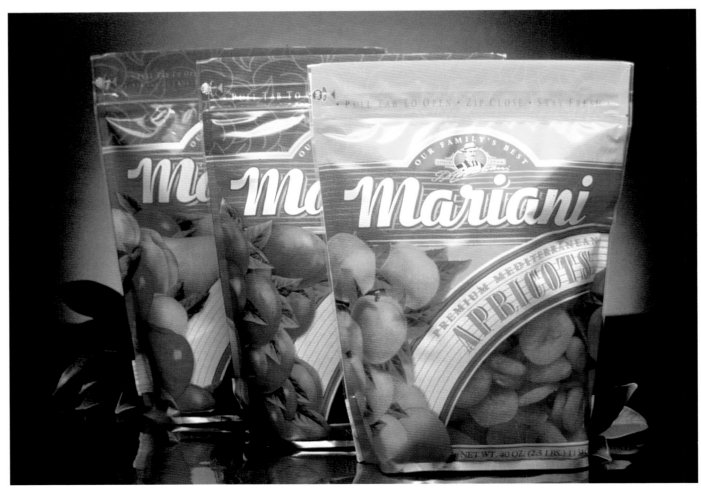

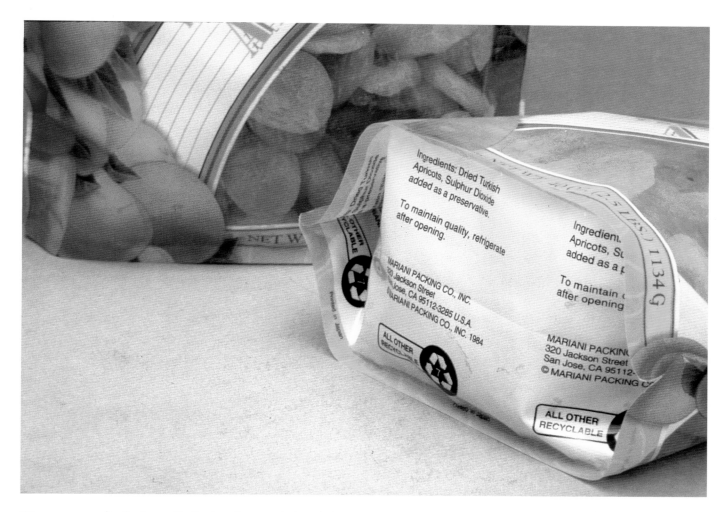

When users are finally done with the bag, the recycled symbol
on the bottom encourages them to recycle it by grouping it
with other similar recyclable plastics.

Design Firm: Primo Angeli, Inc.
Client: Mariani Packing Co., Inc.
Creative Directors: Primo Angeli,
 Carlo Pagoda
Designers: Terrence Tong, Ed
 Cristman
Illustrator: Robert Evans

Nissin Foods Cup

Design Firm: Shimokochi/Reeves
Client: Nissin Foods Co., Inc.
Design Team: Mamoru
 Shimokochi, Anne Reeves
Printer: Everett Graphics Inc.

Shimokochi/Reeves recently completed this package design for Nissin Foods' new meal-in-a-cup product line, Noodles and Sauce. Nissin is well known for producing microwaveable soups in a cup, but it has always relied on packaging its soups in plastic-wrapped, foam containers that functioned equally well on the shelf and as a means of heating and serving hot soup.

When Nissin executives made the decision to produce the new product line, they decided to respond to Shimokochi/Reeves' suggestion that they package their product in a more ecologically sound container. The designers and Nissin agreed on a double-wrapped, thermally insulated paper cup. The cup is a stock item that can be purchased from California Environmental Cup, Inc.

Like most food manufacturers,

Nissin is concerned with the taste appeal and shelf impact of its product packaging. The new packaging provides a smooth, white surface that can easily accommodate the flexo printing of a product photo. Because product labeling is done directly in the container, there's no need for a printed paper sleeve.

In addition to conserving materials, the new container is constructed of paper, which biodegrades more rapidly than plastic foam. The new container functions just as well in the microwave as the shrink-wrapped foam container typically used for this type of product. The paper container costs a bit more than a shrink-wrapped foam container, but Nissin and Shimokochi/Reeves believe that the environmental benefits of the new container outweigh the extra cost.

This thermally insulated paper cup is an environmentally sound alternative to the shrink-wrapped plastic foam containers typically used for meal-in-a-cup food products.

The OXO company has built its reputation on marketing user-friendly gardening tools and kitchen utensils with easy-to-grip handles. With the introduction of its Good Grips barbecue set, OXO wanted to depart from the slip tags used to package its other products.

The designers at Hornall Anderson Design Works decided to package the barbecue set in a natural kraft box. The kraft box uses no glue in its assembly and contains a kraft insert to stabilize the product. Because the designers felt the barbecue set didn't need overly commercialized packaging to sell itself, the product photo and name were offset printed on kraft paper in red, black and white. The kraft paper was then laminated onto corrugated cardboard.

Industrial kraft paper is one of the most eco-friendly packaging materials the designers could have chosen, but their reason for selecting it was motivated as much by their client's marketing objectives as it was by concern for the environment. After researching the competitive products, it became apparent that most barbecue sets were packaged in glossy boxes. The brown kraft box stands in marked contrast to its competitors.

Not only does the kraft box stand out on the shelf, it also looks more upscale than its slick competition because the simplicity of a closed, kraft box is generally perceived by consumers as containing a higher quality product than a plastic sleeve, glossy coated box, or a box with a window in it.

This natural kraft box is not only environmentally correct— it conveys the impression of a more upscale product than a plastic sleeve or a glossy box with a window in it.

Design Firm: Hornall Anderson Design Works
Client: OXO
Design Team: Jack Anderson, Heidi Favour, John Anicker, David Bates
Printer: Rand-Whitney

Broadmoor Baker's line of Italian breads are packaged simply in brown kraft bags.

When Broadmoor Baker contacted Hornall Anderson Design Works about designing packaging for its new line of Italian baked goods, the Seattle-based bakery wanted to develop a brand identity with a traditional Italian look. Hornall Anderson had already developed a branding system for the baker's existing product line, however the design team needed to expand the baker's market share with a new image that was distinctly different.

Because the breads are made from all natural ingredients, the designers chose to convey a natural look by manufacturing bags from industrial kraft paper. The bags also represent the most minimal approach possible—using a box or any other container would have added needless weight and bulk.

The kraft bags were chosen not only for their eco-soundness, but also because the bags' earthy look projects an Old World, European look associated with freshly baked bread.

The packaging's red, green and white inks, the colors of Italy's flag, give the bags an authentic Italian look. The bags were printed using conventional offset.

Design Firm: Hornall Anderson
 Design Works
Client: Broadmoor Baker
Design Team: Jack Anderson, Mary
 Hermes, Leo Raymundo
Printer: Moser Bag

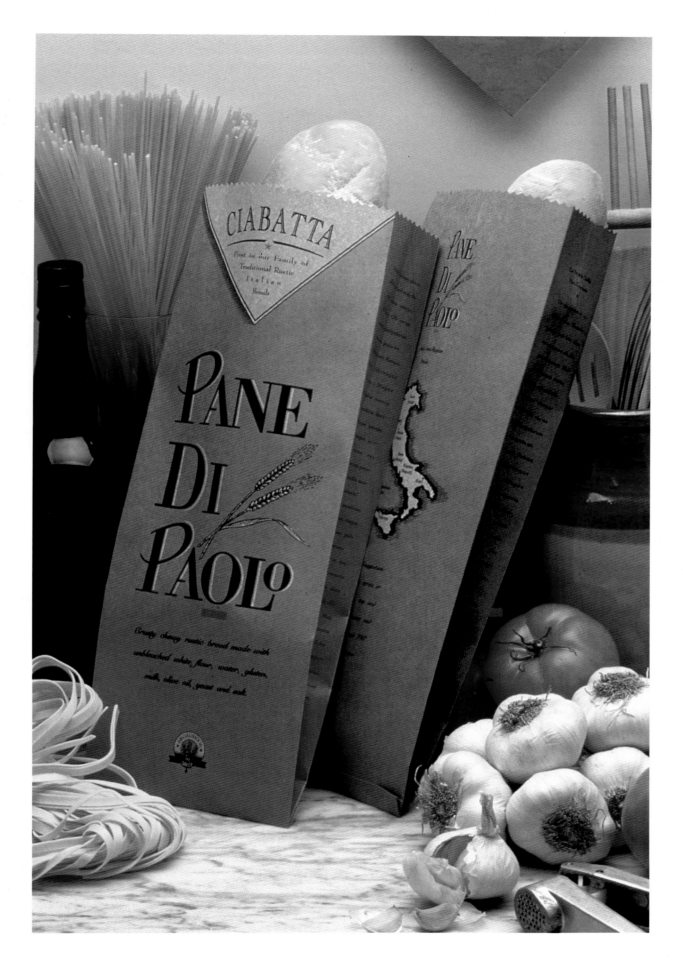

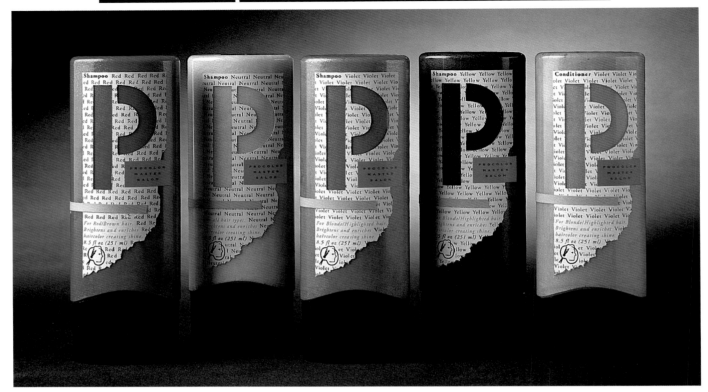

The die-cut P in this label design adds another color without the expense of additional ink by allowing the color of the shampoo to show through.

Design Firm: The Brian Collins
 Studio/Minneapolis
Client: ProColor Master Salons
Designer: Brian Collins
Printer: Web Printing

When Brian Collins, principal of The Brian Collins Studio was commissioned by ProColor Master Salons to create packaging for new hair-care products, he was very clear on what he felt his client should avoid. "We wanted to design a brand identity that clearly broke with the pseudo-earthy, chipboardy, 'I listen to Enya' look that has been so prevalent in high-end cosmetics packaging," said Collins. "Our goal was to create a simple, memorable brand architecture that can be easily extended to a range of products."

Limited in his use of color by a tight budget, Collins decided to incorporate the product color into the label design by using a die-cut *P* as the primary graphic. The window created by the *P* allows the color of the shampoo to show through. The yellow band wrap is used by individual salons to personalize the bottles with an imprint of their own name.

The shampoo containers are actually unused bottles originally purchased by the client for another product idea. When plans for the product were abandoned, ProColor planned to discard the bottles. ProColor didn't ask Collins to incorporate the unused bottles into his design, and Collins initially didn't like the bottles. "But when I flipped them upside down, they looked a lot better," he explained. Using the bottles recovered materials that would have otherwise gone into the waste stream. The upside-down approach also allowed the packaging to function better. "You never have to shake the bottle to get the shampoo out," said Collins.

Collins would have preferred to use vegetable-based inks and recycled paper for the bottle labels, but he was restricted to a more conventional approach that would allow the labels to hold up under shower usage.

The packaging has been so successful, that ProColor is extending the range of its new hair products sooner than originally planned.

Q101 Radio Promotional CD Packaging

Chicago radio station Q101 is well known for broadcasting alternative music. As an on-air promotion, the station gave away *Transmissions from Self-Pollution Radio*, a CD recording of a radio broadcast hosted by Pearl Jam's Eddie Vedder.

The station's executives asked designer Carlos Segura to come up with a "bootlegged" look for the CD's packaging. "They purposely wanted it 'raw,' " he related. Segura obliged with a spontaneous look for the CD's insert. The list of tracks on the CD was reproduced directly from the fax the station sent Segura—nothing was typeset. Segura asked his printer to pick the cheapest recycled paper he could find for the insert to be certain that the paper would be as nondescript as it is environmentally correct.

The spare look of the CD's package comes from the chipboard container, purchased from Calumet Carton, a company that specializes in chipboard mailers and packaging. Segura chose not to print directly on the container, instead adding a self-adhesive label printed with the bell motif used on the insert. The label also seals the container and eliminates the need for an additional closure.

The only image used in the package's production is an illustration of a bell purchased from Bettman Archives. The packaging achieves a lean, rugged look through economical use of materials and processes.

Design Firm: Segura Inc.
Client: Q101 Radio
Designer: Carlos Segura
Printer: MTG Productions

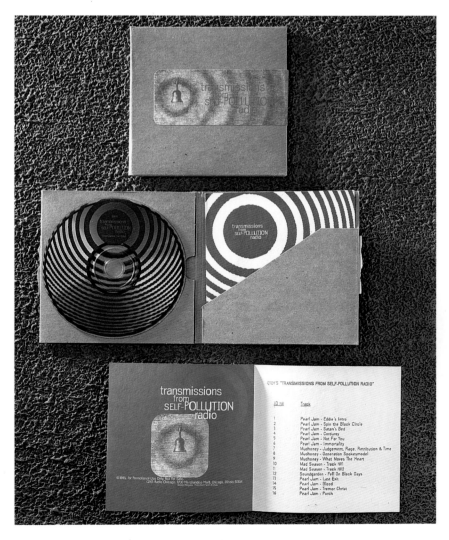

The bootlegged look of this CD packaging is achieved with raw materials and typographic treatment—copy was printed "as is" from a fax.

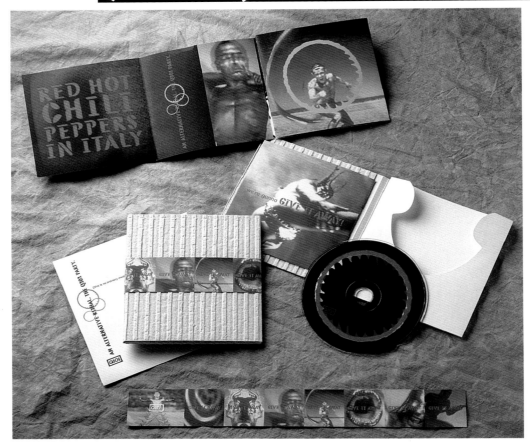

Design Firm: Segura Inc.
Client: Q101 Radio
Designer: Carlos Segura
Photographer: Laura Alberts
Printer: Wicklander Printing
Screen Captures: Tony Klassen

"This is no ordinary invitation" states this party invitation that includes a CD recording. It was mailed in a package constructed from a Japanese recycled paperboard with a rich knitlike texture.

Chicago-based radio station Q101 hosts a party every year for advertisers and media buyers in the local area. Among the highlights of the station's 1995 party was a drawing for a trip for two to Milan, Italy, to attend a concert by the rock group Red Hot Chili Peppers. The station commissioned designer Carlos Segura to come up with an unusual invitation for this event that would incorporate a CD recording of live studio performances by musicians featured on the station throughout the year.

Although Segura wanted to somehow convey an Italian theme, an Old World, ethnic look would have been totally inappropriate for this alternative music station. He decided instead to go for the look of an Italian knit. "I wanted it to look 'fashiony,' " said Segura, who used an unusual Japanese recycled paperboard with a rich "sweatery" texture for the CD's packaging. The paperboard, available in three colors through Kamiyama, a paper distributor in Arlington Heights, Illinois, was pricey; however, Segura says the cost was justified for this unusual mailer—its raw, yet sophisticated look is exactly what he was looking for to complement the colorful shots of the rock group in concert that appear on the invitation.

The foldout insert and exterior belly band are printed in four colors on Weyerhauser Cougar, a paper comprised of 20% postconsumer waste. Segura used video captures from a Red Hot Chili Peppers concert video for the "live-action" visuals.

The CD packaging cost more than a standard plastic jewel case but is an environmentally sound alternative in its use of eco-friendly materials that are easily recycled.

Blue Willow Tea Packaging

The Blue Willow Tea Company is a Seattle-based tea distributor of natural, loose-leaf teas and tea products. When the company decided to create a retail line of fifteen teas, it approached Partners in Design to develop packaging that reflected the company's eco-friendly philosophy.

Designers Sharon Mentyka and Stephen Schlott suggested a container made of kraft board, a 100% recycled product composed of 40% postconsumer waste.

Blue Willow sells three categories of teas: herbal, black and green. For each category, a unique color was selected. The selected colors do not exceed current EPA specified threshold levels for copper or barium. The remaining match colors (black, white and blue) are common among all fifteen tea varieties. These common colors allowed for fewer press washups and best printing value.

Working in collaboration with the printer and the ink manufacturer, draw downs were done of the soy-based inks selected to test the effect of the kraft stock on the colors. To maintain the company's logo blue, a pass of white beneath the color was necessary.

To distinguish each variety of tea, specific information was printed on labels affixed to the boxes. Printing the labels provided Blue Willow with a flexible system for handling inventory changes. Teas that are discontinued won't result in discarded boxes, and new teas can easily be added to the line by printing new labels. The labels also do double duty as a seal, pre-empting the need for exterior plastic shrink-wrap.

Although the designers wanted the labels to be run on a recycled stock, they point out that, in their experience, paper options are limited to what label makers are willing to provide. They also found that label papers that suppliers describe as "recycled" are usually low in recycled content.

Despite the limitations of label papers, the Blue Willow Tea box exemplifies eco-sensitive design in every other aspect—even the glue used to construct the box is biodegradable.

Design Firm: Partners in Design
Client: Blue Willow Tea Company
Design Team: Sharon Mentyka,
 Stephen Schlott
Printer: Rose City Paper Box,
 Richmark Label

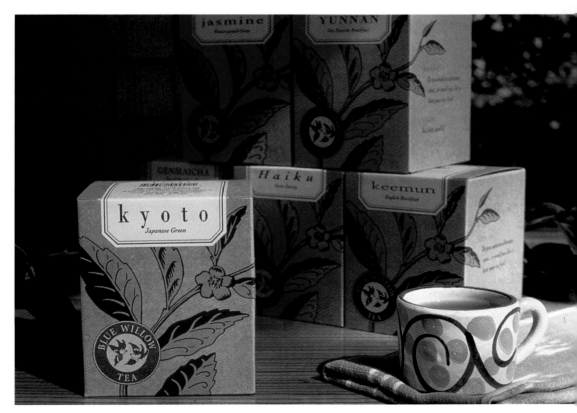

Blue Willow Tea's packaging makes use of an interchangeable label system for identifying each tea variety. The labels ensure that discontinued tea lines won't result in discarded boxes.

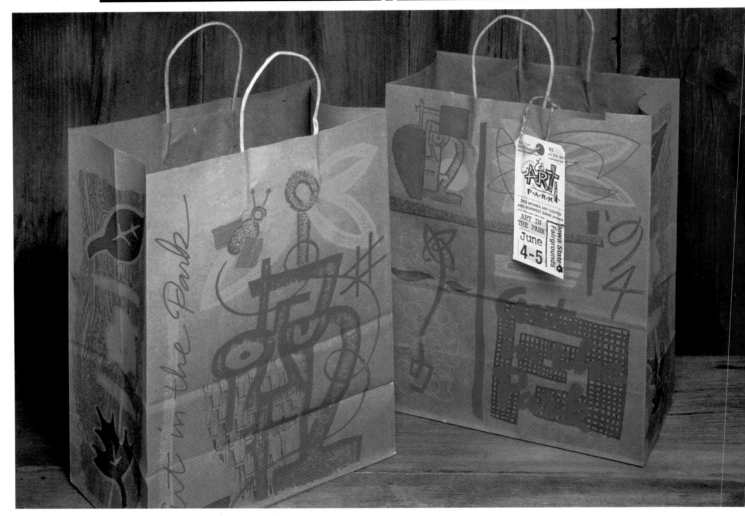

Art in the Park is a two-day art festival held every year at the Iowa State Fair Grounds. John Sayles, designer of the event's 1994 poster, decided to play up Iowa's reputation as an agricultural state by printing the posters on feedbags.

Seven hundred feedbags, donated by a local manufacturer, enabled the Des Moines Art Center to save money that otherwise would have been spent on paper. The feedbags were also an environmentally sensitive choice—they're made of industrial kraft, a 100% recycled paper.

To encourage others to reuse the bags, a removable manilla hang tag attached to each bag contains information specific to the event. The "art" on the bag,

screen printed in three colors, is a delightful contrast with the rustic, function-oriented look of the feedbag.

Sheree Clark, director of client services for Sayles Graphic Design, pointed out that the poster bags offered advantages over traditional posters. They could be tacked or taped onto flat surfaces or stuffed with old newspapers to make a three-dimensional display. "We put them in the lobby of a bank," she said, describing how the posters were able to stand alone at the tellers' windows.

To coordinate with the posters, the same motif was printed on industrial kraft shopping bags that art lovers used to carry home their Art in the Park purchases.

<u>above</u>
Art collectors took their purchases home in these kraft shopping bags, screen printed with the poster motif.

<u>right</u>
Screen printing posters on natural kraft feedbags allowed event promoters to make three-dimensional displays by stuffing the bags.

Design Firm: Sayles Graphic Design
Client: Des Moines Art Center
Designer: John Sayles
Illustrator: John Sayles
Printer: Imagemaker

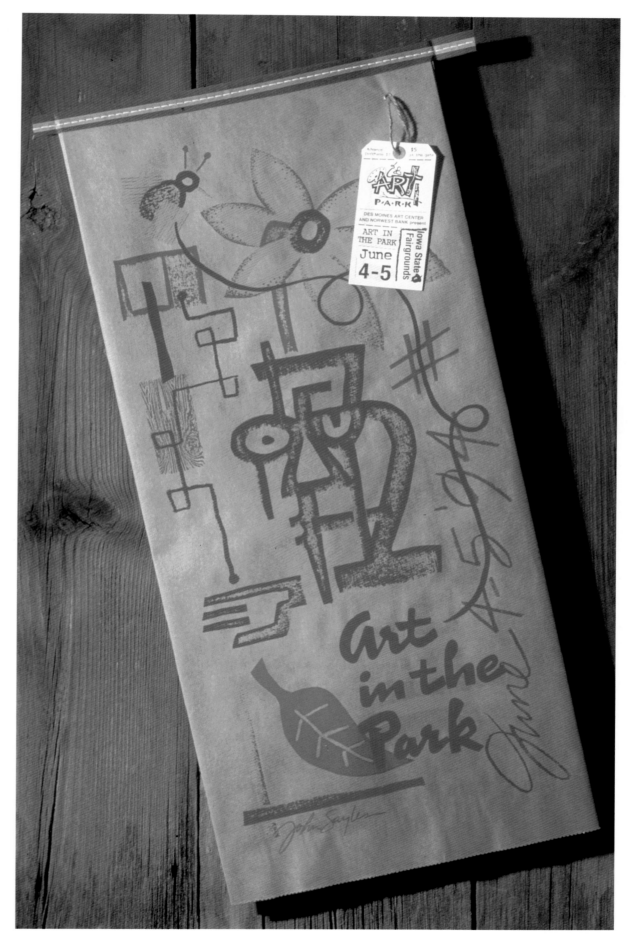

Madison Repertory Theatre needed a poster to promote its performance of *The Crucible*. The theater group contacted Planet Design Company in Madison, Wisconsin, requesting a poster design that would give them maximum impact on a small budget.

Planet Design principals Kevin Wade and Dana Lytle came up with the idea of a diptych—two posters, one each of a man and woman, which would depict the two in conversation when the posters were hung side-by-side. Kevin Wade produced black-and-white illustrations and hand-lettered type with an appropriately caustic look. Wade's coarse illustration style ties in with the play's theme and the rugged look

of the poster's paper.

The posters, measuring 9" x 24" each, were printed two-up on odd-sized waste sheets of Simpson Evergreen, a 50% recycled sheet. Because the paper for the job was waste stock leftover from a previous job, the posters were printed on two different but coördinating colors. The pairing of the two colors of paper gives the impression of a two-color job with a single pass of black ink.

In addition to salvaging leftover paper, this project exemplifies smart, economical design in another aspect: Although the two posters appear to be different pieces of art printed as two separate print runs, the posters were actually printed front to back with both images (the poster depicting the man appears on the back of the poster of the woman, and vice versa). In addition to economizing on the print run, printing the images front-to-back doubled their impact. When the two posters were displayed in store windows, they worked just as effectively indoors as well as outside.

Wade and Lytle make it a practice to employ as many eco-friendly practices in their projects as possible. As a result, the posters were printed with soy-based inks and were designed with as little ink coverage as possible.

These posters are actually the same poster, printed front-to-back with different illustrations on different colored paper. The posters were printed with soy-based inks on leftover paper salvaged from a previous job.

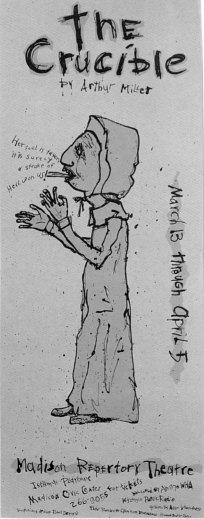

Design Firm: Planet Design Company
Client: Madison Repertory Theatre
Design Team: Kevin Wade, Dana Lytle
Illustrator: Kevin Wade
Printer: Adtec Lithographics

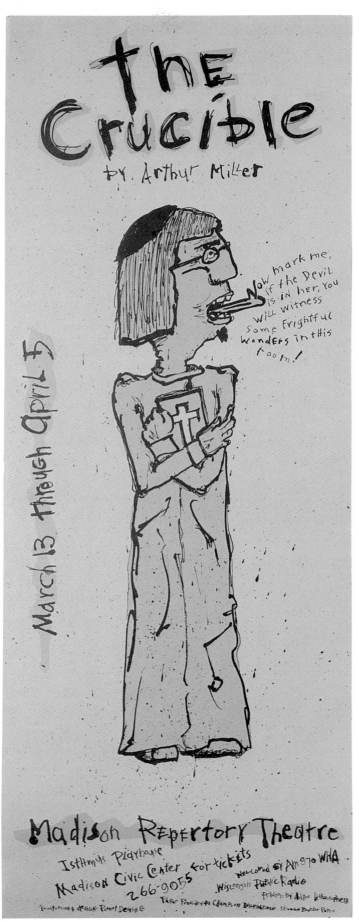

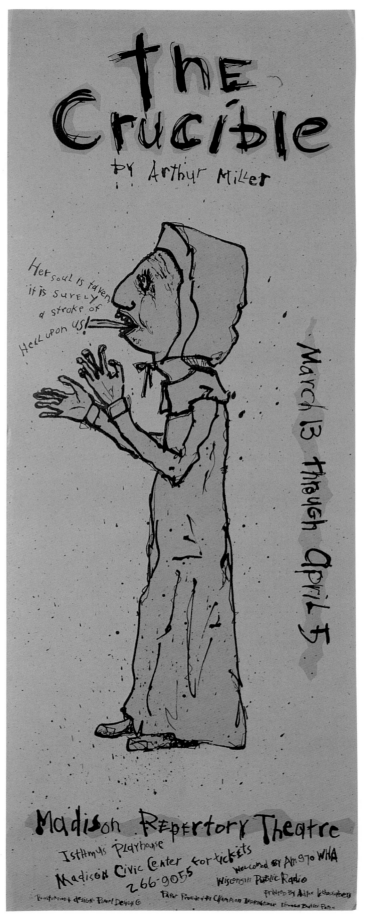

Design Firm: Various
Client: Earth Day New York
Designers: Ivan Chermayeff,
 Seymour Chwast, Paul Davis,
 Louise Fili, Milton Glaser,
 Jennifer Morla, Woody Pirtle,
 Paul Rand, Paula Scher,
 Michael Vanderbyl
Prepress: Axiom, Speed Graphics,
 X & Co.
Printers: Berman Printing,
 Panorama Press

As part of New York City's 1995 Earth Day celebration, a special series of posters was commissioned from ten of the country's most distinguished designers. The posters needed not only to convey the spirit of Earth preservation, they also needed to be produced in the most environmentally sound way possible. Seymour Chwast of the New York City-based Push Pin Group recruited the designers involved in this effort and produced a poster as well.

When all designs were completed, Rick London, managing director of Second Nature Graphics, took charge of getting the posters produced. "It all had to be done pro bono," said London. "I thought the best thing to do would be to spread the work around." As a result, five of the posters were printed by Second Nature Graphics' parent company, Clifton, New Jersey-based Panorama Press, while the other five went to Berman Printing in Cincinnati. Panorama Press used vegetable-based inks and an environ-

mentally friendly printing process called dryography, or waterless printing, which uses no alcohol or water.

But before the job was printed, a substantial amount of prepress work needed to be done. Each of the designers who produced the posters had a different way of producing final art. One supplied an oil painting, whereas another submitted digital files on a SyQuest cartridge. Others submitted pasted-up mechanicals. "We decided to standardize the job by putting everything on disk," explained London. Converting all of the posters to digital format saved on film and other resources and made the job much easier to manage.

Speed Graphics, a New York City-based firm, converted all of the posters into digital format and stored the files on SyQuest cartridges. SyQuest cartridges with the digital files went to several service bureaus in the area, which donated their time to make films. After the designers had seen and approved chromalins of their poster, the films were sent to the printers.

The posters were printed on six-color presses on Potlatch Quintessence Remarque Velvet text, an elemental-chlorine-free sheet, which was chosen for its 50% recycled content and smooth, coated surface. A deinkable spot varnish was applied in-line to Woody Pirtle's poster.

Scratching beneath the surface of an issue is how Ivan Chermayeff felt we should solve our environmental problems.

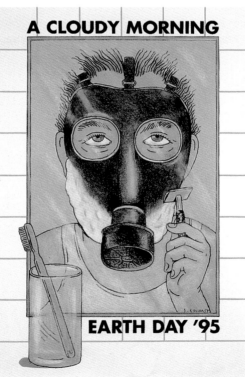

Seymour Chwast used an ironic image to show the effects of air pollution.

Using life-affirming metaphors, Louise Fili's poster brings vintage imagery to a contemporary cause.

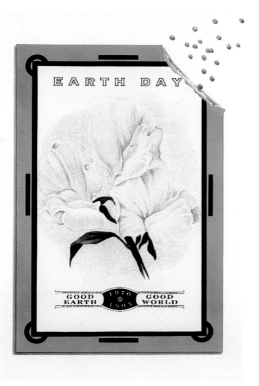

Paul Davis chose to convey that our delicate environment is in our hands.

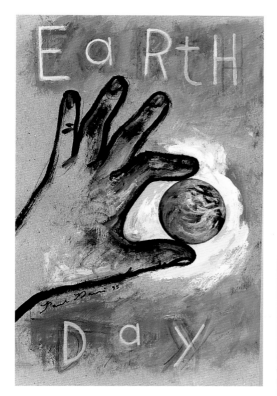

Milton Glaser's poster focuses on two things that are important to the quality of our lives.

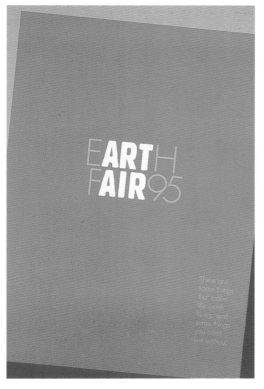

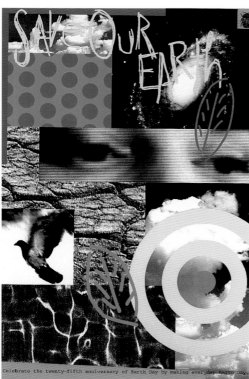

Jennifer Morla's poster conveys the complexity of environmental issues with a collage of symbols and images.

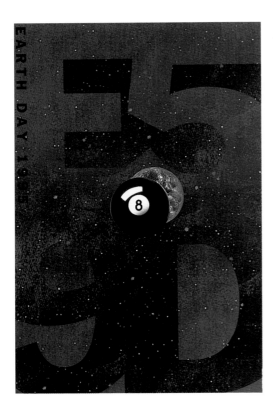

Behind the eight ball on the pool table of the universe is how Woody Pirtle chose to depict the Earth's future.

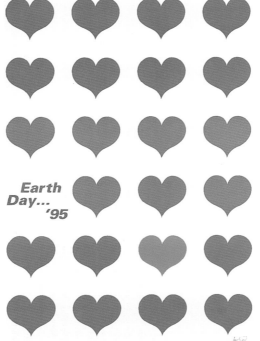

Paul Rand used the heart as a symbol of life to convey our connection with our environment.

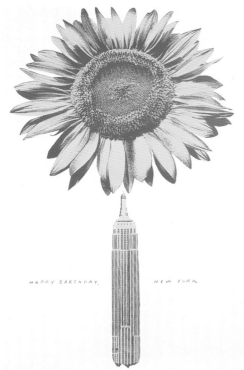

Paula Scher chose to celebrate Earth Day 1995 with a cheerful twenty-fifth anniversary poster.

Michael Vanderbyl wanted to show the tension between our abilities to destroy the Earth (by squashing it) and to hold it in delicate balance.

Alabama AIGA/Brian Collins Poster

To promote his speaking engagement at a meeting of the Alabama chapter of the AIGA, designer Brian Collins came up with a poster idea that supports the theme of his discussion, topics from a book he co-authored, *The Ecology of Design.*

Printed in three colors with vegetable-based inks, the poster features an abstract image of a designer and a bird on one side. The paper used for the poster is Cross Pointe Aquarius, a non-chlorine-bleached paper of 20% postconsumer waste.

The opposite side of the poster includes details on the event and an illustration of a bird with an envelope in its beak. The 22" x 35" poster was folded to allow the envelope in the bird's beak to serve as the addressee area for the poster. Making the poster a self-mailer eliminated the need for an envelope and saved labor and money as well as paper. The placement of a mailing stamp and cancellation mark added a third color to the two colors used on this panel of the poster.

Design Firm: The Brian Collins
 Studio/Minneapolis
Client: Alabama AIGA
Designer: Brian Collins
Illustrator: Brian Collins
Printer: Boaz Printing

When folded for mailing, this poster eliminates the need for an envelope by incorporating one of the poster images into the address panel.

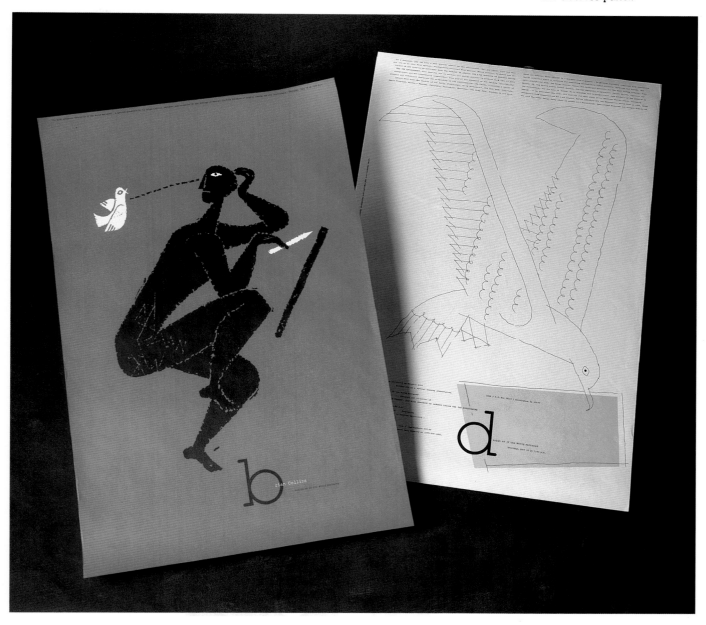

Sandjam is a sand castle building contest held annually in Des Moines to which architects, engineers and designers are invited to compete for the honor of building the most spectacular sand castle. Promoting Sandjam '94 required a unique poster that would capture the playful spirit of the event and catch the attention of the local community.

Designer John Sayles, of Sayles Graphic Design, came up with a design solution that combines a bold illustrative style with a unique twist—each poster includes a small shovel to commemorate the event. The chipboard shovel is die-cut from a die originally constructed in the shape of a hamburger flipper. Recycling a previously used die conserved materials and labor and resulted in a less expensive poster.

Four hundred of the posters were screen printed in black on corrugated cardboard, an industrial stock. After the shovels had been attached with rubber bands, the posters were distributed to local merchants who placed them in their windows. Merchants were happy to comply because the rigidness of the corrugated cardboard allowed the posters to be propped against the glass rather than taped.

The die used to cut this hamburger flipper was slightly altered to die-cut the shovel on the Sandjam poster.

This poster, printed on corrugated cardboard,
includes a small shovel cut from a recycled die.

Design Firm: Sayles Graphic
 Design
Designer: John Sayles
Illustrator: John Sayles
Printer: Imagemaker

Design Firm: Partners in Design
Client: AIGA/Seattle
Designer: Sharon Mentyka
Printers: George Rice & Sons,
 Printery Communications,
 Litho Craft, Heath Printers

This series of four posters was produced as part of a peer education project for graphic designers in the Pacific Northwest. Funded by a grant from the Puget Sound Water Quality Authority and substantial contributions from the local print and paper industries, the posters were distributed free at workshops on environmentally sensitive design and nationally by request through the AIGA/Seattle.

The posters have a twofold purpose: First, and foremost, they encourage environmental awareness with dramatic photography and copy that describes the vulnerability of the area's ecosystem. But the posters also demonstrate how environmentally sensitive practices can be utilized on a variety of papers with various inks and printing methods.

Run two-up on a 25" x 38" sheet, all four 17" x 22" posters make economical use of the sheet size and press on which they were run. The posters also use minimal ink—no more than 35% coverage. Four-color visuals are confined to a small area but sustain their impact as a result of each poster's textural border of duotoned visuals of river rocks, evergreen needles, seaweed and shellfish. To aid in the deinking of the posters' trim, the borders were vignetted so that the trimmed waste wouldn't need to be deinked when recycled as preconsumer waste.

On the back of each poster, extensive production notes explain the eco-sensitive measures taken in each poster's production. To accommodate the wide variety of papers, inks and printers involved in the project, a predetermined design aesthetic was set aside and the designers let themselves be open to new ways of working with alternative materials.

This poster was printed on Island Paper Mills ReSolve Natural. [Island Mills is a Canadian paper manufacturer that can be contacted at (604) 527-2500.] It contains 50% postconsumer waste, deinked waste purchased from sources that certify their pulp is elemental chlorine free, and 50% totally unbleached pulp. The printer, George Rice & Sons, Seattle, compensated for the heavy color of the paper when scanning and calibrating the four-color transparency for reproduction. The four-color image was wet-trapped over the top of a solid window of opaque white ink. Vegetable- and soy-based inks were used on a conventional offset press.

(Left) Printed on Neenah Classic Crest, a 60% recycled sheet with a minimum of 30% postconsumer waste, this absorbent paper required compensation for the dot gain typical of uncoated recycled sheets. Decreasing the size of the dot before the plates were made helped to compensate for this. The printer, Printery Communications, used vegetable-based inks on a waterless press for their environmental advantages.

(Above) This poster proves that a recycled coated paper can produce results that are just as dramatic as virgin coated sheets. Ozone, a Japanese-made paper with 80% postconsumer content, is made by the Honshu Paper Company and distributed to local paper merchants by Dai Ei Papers. [Contact them at (415) 697-8311.] The poster was printed with vegetable-based inks by Litho Craft, Seattle, on a press running 100% alcohol free.

(Left) Simpson Quest, a 100% recycled paper made entirely from non-deinked postconsumer waste, was used for this poster. The poster was printed by Heath Printers using SoyaPlus™ soy-based inks on a 100% alcohol-free press. The poster demonstrates how the specks that remain in non-deinked papers can enhance the design.

All images have been reproduced with the knowledge and consent of the artists concerned.

Page 12, Bruce Licher "Junkyard Dog" © Bruce Licher.

Page 13, (top) EcoLogo © Environment Canada; (bottom) © 1993 Tharp Did It. Photo: Kelly O'Connor.

Page 15, Victoria Paper © Victoria Paper Company, Inc. These papers are imported by the Victoria Paper Company, Inc., based in New York. They may only be reproduced by permission of VPC for educational purposes.

Page 17, Jerusalem Paper © Jerusalem Paperworks.

Page 24, National Soy Ink Information Center Logo © American Soybean Association.

Page 29, Mariani Dried Fruits © Primo Angeli Inc. Photo: June Fouche.

Page 31, Charles S. Anderson Wristwatches © CSA Archive. Photo: Daryl Eager.

Page 33, © CSA Archive. Photo: Andy Kingsbury.

Page 37, Purgatory Pie Press © Purgatory Pie Press. Design: Wim Hurrman (Lunatic Rage Afar, Chains of Memories Collage); Melinda Beck (Window Pain); Laura Murawski (Fandango).

Page 39, Shopping Bag © Starbucks Coffee Company and Hornall Anderson Design Works. Slides: Tom McMackin.

Page 47, Roland Companies X-ray Promotion © 1994 Richardson or Richardson.

Page 48, Flyers © Drentell Doyle Partners.

Page 50, National Soy Ink Information Center Logo © American Soybean Association; Scientific Certification Systems Logo © Scientific Certification Systems; EcoLogo © Environment Canada.

Page 51, (top) Brochure © Studio MD; (bottom) Brochure © Sayles Graphic Design. Photo: Bill Nellans/GYZNIWA.

Pages 54-55, National Audubon Society Annual Reports © National Audubon Society and Jenkins & Page Design.

Page 57, Bernhardt-Fudyma Self-Promotional Brochure © Bernhardt Fudyma Design Group. Photo: Earl Ripling.

Page 59, British Petroleum Company Annual Report © Nesnadny + Schwartz. Photo: Design Photography, Inc.

Page 61, Cleveland Institute of Art Recruitment Brochure. © Nesnadny + Schwartz. Photo: Design Photography, Inc.

Page 63, Cross Pointe Medallion Sketchbook © 1995 Cross Pointe Paper Corporation.

Page 64, Carnegie Libraries Brochure © DeWitt Kendall.

Page 65, Cutler Travel Marketing Brochure © Sayles Graphic Design. Photo: Bill Nellans/GYZNIWA.

Pages 66-67, Des Moines Metropolitan Area Solid Waste Agency Annual Reports © Metro Waste Authority.

Page 68, Fox River Confetti's Intolerance Brochure © Fox River Paper Company and Rigsby Design, Inc. Photo: Gary Faye, Bruce Barnbaum, Keith Carter.

Page 69, LTV Corporation Annual Report © Nesnadny + Schwartz. Photo: Design Photography, Inc.

Pages 70-71, Des Moines Metropolitan Area Solid Waste Agency Brochure © Metro Waste Authority.

Page 72, Metro Waste Authority Annual Report © Metro Waste Authority.

Page 73, Metro Waste Authority Flash Cards © Metro Waste Authority.

Page 74, Drake University Greek Life Brochure © Sayles Graphic Design. Photo: Bill Nellans/GYZNIWA.

Page 75, AIGA/Seattle Sound Design Materials © AIGA/Seattle. Photo: Ben Kerns, Stephen Schlott, Joel W. Rogers.

Pages 76-77, VH-1 "Honors" Event Program © Werner Design Werks Inc. Photo: RipSaw Photography.

Page 78, Werner Design Werks Logo Book © Werner Design Werks. Photo: Darrell Eager.

Page 79, Starbucks Annual Report © Starbucks Coffee Company and Hornall Anderson Design Works. Slides: Tom McMackin.

Page 80, The Hackett Group Brochures © Nesnadny + Schwartz.

Page 81, DeWitt Kendall Stationery System © DeWitt Kendall.

Pages 82-83, Acme Rubber Stamp Stationery System © Peterson & Company.

Pages 84-85, Bruce Rudman Capabilities Brochure and Business Card © Studio MD.

Page 86, American Zoo and Aquarium Materials © Grafik Communications Ltd.

Page 87, League of Conservation Voters Identity System © Grafik Communications Ltd.

Pages 88-89, Arum Rose Business Card © Clare Helfrich; Fuller Barnes Business Card © Ron Burns; Miriam Kaplan Business Card © Bruce & Karen Licher; Christina Taccone Business Card © Karen Licher.

Page 90, Italia Letterhead © Italia and Hornall Anderson. Design Works, Inc. Slides: Tom McMackin.

Page 91, Blue Willow Tea Stationery © Partners in Design.

Pages 92-93, RadioActive Ink Identity System © Werner Design Werks. Photo: Paul Irmiter.

Pages 94-95, Loews Hotels Stationery System © Lebowitz/ Gould/Design, Inc. Photo: Joseph Sachs.

Page 96, Ecodea Self Promotional Brochure © 1990 Richardson or Richardson.

Page 97, Gilbert ESSE Sales Kit © Grafik Communications Ltd. Photo: Claudio Vazquez.

Pages 98-99, Cross Pointe Genesis Promotional Brochure © 1995 Cross Pointe Paper Corporation.

Page 100, Napa Valley Grille Wine List © Tharp Did It. Photo: Kelly O'Connor.

Page 101, Hornall Anderson Holiday Card © Hornall Anderson Design Works.

Pages 102-103, R.E.M. Holiday Card © Independent Project Press.

Page 104, Rushdie Defense Committee Flyer © Cameron Manning.

Page 105, 3M Patient Comfort System Identity © Brian Collins Studio. Photo: Paul Sinkler/ Minneapolis.

Pages 106-107, Starbucks Coffee Shopping Bag © Starbucks Coffee Company and Hornall Anderson Design Works.

Pages 108-109, Ann Taylor Packaging © DesGrippes Gobé & Associates. Photo: DesGrippes Gobé & Associates.

Page 110, The Gap Shoe Box Prototype © Tharp Did It. Photo: Kelly O'Connor.

Page 111, Candinas Chocolates Packaging © Planet Design Company. Photo: Mak Salisbury.

Pages 112-113, CSA Archive Product Packaging Tins © CSA Archive. Photo: Daryl Eager; Magnetic Personalities Steel Tin © CSA Archive. Photo: Andy Kingsbury.

Page 114, Just Desserts Biscotti Packaging © Primo Angeli, Inc. Photo: June Fouche.

Page 115, Loews Hotels Guest Amenities. © Lebowitz/Gould/ Design, Inc. Photo: Joseph Sachs.

Pages 116-117, Mariani Dried Fruit Packaging © Primo Angeli, Inc. Photo: June Fouche.

Page 118, Nissin Foods Cup © 1995 Shimokochi/Reeves.

Page 119, OXO "Good Grips" Barbecue Set Box © OXO International and Hornall Anderson Design Works. Slides: Tom McMackin.

Pages 120-121, Broadmoor Baker Bread Packaging © Broadmoor Baker and Hornall Anderson Design Works. Slides: Tom McMackin.

Page 122, ProColor Shampoo Bottle © Brian Collins Studio. Photo: Paul Sinkler/Minneapolis.

Page 123, Q101 Radio Promotional CD Packaging © Segura Inc.

Page 124, Q101 Radio Party Invitation © Segura Inc.

Page 125, Blue Willow Tea Packaging © Partners in Design. Photo: Stephen Schlott.

Pages 126-127, Art in the Park Poster and Shopping Bag © Sayles Graphic Design. Photo: Bill Nellans/GYZNIWA.

Pages 128-129, Madison Repertory Theatre Poster © Planet Design Company.

Page 130, Earth Day New York Posters © Earth Day New York 1995. Design: Ivan Chermayeff (left), Seymour Chwast (right).

Page 131, Earth Day New York Posters © Earth Day New York 1995. Design: Louise Fili (top right), Paul Davis (top left), Milton Glaser (bottom left), and Jennifer Morla (bottom right).

Page 132, Earth Day New York Posters © Earth Day New York 1995. Design: Woody Pirtle (top left), Paul Rand (top right), Paula Scher (bottom left), and Michael Vanderbyl (bottom right).

Page 133, Alabama AIGA/Brian Collins Poster © Brian Collins Studio. Photo: Paul Sinkler/ Minneapolis.

Pages 134-135, Sandjam Poster © Sayles Graphic Design. Photo: Bill Nellans/GYZNIWA.

Pages 136-137, AIGA/Seattle Sound Design Posters © AIGA/Seattle. Photo: Ben Kerns, Stephen Schlott, Joel W. Rogers.

GLOSSARY

ACF (ABSOLUTELY CHLORINE FREE) Describes pulp and paper that have been bleached without chlorine or chlorine compounds.

ACID-FREE PAPER Paper made from pulp containing little or no acid. Acid-free paper resists deterioration and is appropriate for archival use.

AOX (ABSORBABLE ORGANIC HALOGEN) General term for measuring the total amount of chlorine bound to organic compounds.

BRIGHTNESS The degree to which a paper reflects light.

CANOLA Vegetable oil used in Canada as an alternative to petroleum as a vehicle for inks.

CHIPBOARD An industrial board composed of 100% recycled materials. Unbleached.

CHLORINATED COMPOUNDS Synthetic chemicals that are formed in the chlorine bleaching of pulp. Also called *organochlorines.*

COATED PAPER Paper coated with clay and other substances. The coating improves reflectivity and ink holdout. Coated paper comes in four categories: dull, matte, gloss and cast-coated.

CORRUGATED CARDBOARD An industrial stock made of 100% recycled paper. Brown corrugated cardboard is unbleached.

COVER STOCK Thick paper used for posters, menus, pocket folders and brochure covers.

DEINKING A process in recycling that removes inks, finishes, glues and other substances from wastepaper to extract fiber suitable for papermaking. The process typically requires pulping, cleansing and flotation equipment.

DIOXINS A class of chlorinated organic compounds known as dioxins and furans or simply as dioxins. All are proven to be potent carcinogens (cancer-causing agents) in animals other than humans and are suspected of causing cancer and birth defects in humans. Dioxins are an ingredient of Agent Orange and a contaminant in several ecological disasters including those at Love Canal and Times Beach, Missouri.

DOT GAIN The enlargement of the dots that make up the halftone reproduction of photographs in offset printing. Dot gain reduces detail and lowers contrast. Also called *press gain* and *dot spread.*

DRAWN DOWN Sample of inks specified for a job applied to the paper specified for the job.

ECOLOGO The official mark of Environment Canada, the EcoLogo is awarded to products that meet the country's Environmental Choice criteria. For instance, EcoLogo certification for papers requires 50% total recycled content and a minimum of 10% postconsumer fiber.

ECF (ELEMENTAL CHLORINE FREE) Describes pulp or paper that has been bleached without the use of chlorine gas. ECF pulp may have been processed with chlorine compounds, such as chlorine dioxide.

EMBOSS Creating an image pressed into paper by molding the paper around a sculpted die.

EPA METHOD 24 Used to measure VOC (volatile organic compound) levels in ink, this procedure heats a sample of ink under controlled conditions and determines VOC emissions by measuring the sample's weight loss.

FOIL STAMPING Printing an image on paper by adhering a polyester film to the paper with heat. Also called *hot foil stamping* or *foil embossing.*

FOUR-COLOR PROCESS Method of printing that uses magenta, cyan, yellow and black to reproduce full-color images. Mainly used to print continuous-tone full-color images. Also called *full-color printing* and *process printing.*

GLASSINE A semitransparent vegetable parchment often used for envelopes and the window area of window envelopes. Glassine is water soluble and breaks down easily in the recycling process.

GRAIN DIRECTION Primary direction in which paper fibers become aligned during manufacture.

GRAIN LONG PAPER Paper containing fibers that run parallel to the long dimension of the sheet.

GRAIN SHORT PAPER Paper containing fibers that run parallel to the short dimension of the sheet.

GROUNDWOOD PAPER Paper, such as newsprint, made from pulp that is ground mechanically rather than chemically refined. Groundwood papers contain more lignin than other printing papers. Paper without groundwood is called a *free sheet.*

HEMP An herb that produces fibers that can be used for paper and fabric. Also called *cannabis.*

INK HOLDOUT Property of paper that prevents it from absorbing ink. When ink dries on the surface of the paper detail is preserved and colors are more vibrant.

KENAF A plant that produces strong fibers suitable for papermaking and cloth.

KRAFT PAPER A 100% recycled industrial paper that is unbleached and has a brown color. Kraft paper is commonly used for grocery and shopping bags, but it can be printed and used in the same way as fine printing papers.

LIGNIN A binding agent within the structure of trees and other vascular plants that holds fibers together. If not removed, lignin can cause paper to rapidly deteriorate.

LINTING When ink pulls bits of fiber or coating off the surface of the paper as it goes through the press, leaving unprinted spots in the inked area.

LITHOGRAPHY Printing method that uses plates. The image area on each plate attracts ink and the nonimage area repels ink.

METALLIC INK Ink containing powdered metal or pigments that look like metal.

MILL BROKE See *postmill waste.*

OFFSET Printing method that transfers ink from plate to a rubber blanket. Ink is transferred to paper from the blanket rather than directly from the plate.

OPACITY The degree to which a paper blocks light transmission and show-through of printing.

ORGANOCHLORINES Synthetic chemicals formed in the chlorine bleaching of pulp. Also called *chlorinated compounds.*

PAPERBOARD Heavier paper, usually heavier than 80# cover stock and 110# index stock. Used for displays, postcards and packaging. Also called *board paper.*

PICKING See *linting.*

PIGMENT Color-carrying agent in printing inks. Pigments are derived primarily from metals or clays or petroleum by-products.

PLATE Paper, metal, plastic or rubber carrying an image to be printed on a printing press.

POSTCONSUMER WASTE As defined by EPA guidelines, this includes only wastepaper collected from residences, offices and other sources "after they have passed through their end usage as a consumer item."

POSTMILL WASTE Wastepaper recovered after the paper is manufactured but before it reaches consumer hands. Examples include envelope trimmings and mill scrap. Also referred to as *mill broke.*

PRECONSUMER WASTE Wastepaper that is created before a product has reached its final end-user. Includes printed and unprinted scrap from mills, converters, printers, publishers and manufacturers.

PROCESS COLORS Also referred to as the abbreviation CMYK for cyan, magenta, yellow and key (black).

RECYCLED PAPER Paper made entirely, or in part, from used paper.

RESOLUTION The sharpness of an image on paper, film or screen, often measured in dots per inch (dpi).

SOY-BASED INKS Describes inks with a vehicle comprised of soy oil. Percentages of soy oil in "soy-based" inks can vary. The term "100% soy-based ink" doesn't necessarily mean that the total of content of the ink is soy, but rather that the vegetable oil in the ink is 100% soy.

SOY SEAL The American Soybean Association's logo that can be used for the following soy ink formulations: a news ink with at least 55% soybean oil, a sheetfed ink with at least 20%, and a heat-set web ink with at least 18%. These are minimum standards. Many soy ink formulations carry much higher percentages.

TCF (TOTALLY CHLORINE FREE) Describes pulp and paper that have been bleached without chlorinated compounds.

UNBLEACHED PAPER Kraft paper, with its unbleached, brown color, is the only printing paper that is not bleached to some extent.

UNCOATED PAPER Paper not coated with clay.

VEGETABLE-BASED INKS Inks with a vehicle comprised of vegetable oil. Includes inks made from canola and other vegetable oils. Percentages of vegetable oil in "vegetable-based inks" can vary.

VOLATILE ORGANIC COMPOUNDS (VOCS) Substances released into the air during the evaporation of alcohol and petroleum products that can cause air pollution and health problems for those who inhale them.

WIRE SIDE In the papermaking process, the paper side that touches the Fourdrinier wire. Opposite side (not touching the Fourdrinier wire) is called the felt side.

INDEX

More Great Books
for Knock-Out Graphic Design!